POSTCARD HISTORY SERIES

Fort Lauderdale

IN VINTAGE POSTCARDS

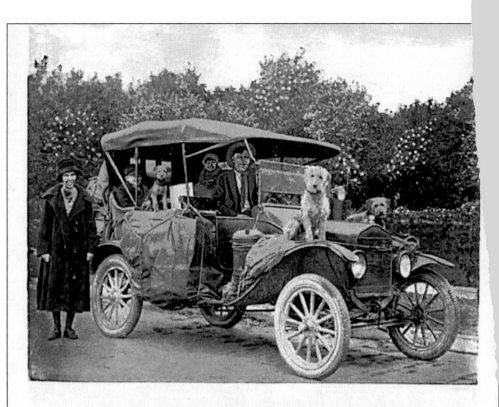

Crank up the Lizzy, an' all git aboard,
 We're goin down south, so hurry up an' load!
I know she rattles, an' the radiator leaks!
 But she'll git us thar safe, even if she squeaks!
Git the axe an' saw, an' the big fryin pan;
 An' the tent an' pegs. An' oh, my lan'!
Don't forgit the matches, an' the ole tire pump!
 Hustle around now, an' keep on the jump!
The weather-man says, thar's a blizzard comin';
 So crank up the Lizzy an' keep er a-hummin'!
Head 'er fer Floridy, as fast as we can go;
 An' we'll beat that blizzard, first thing we know!
We'll pitch our tent, by runnin' stream,
 An' the rest of the winter, 'll be one long dream!
—S.S.R.

Pivotal in the development of Fort Lauderdale, the land boom of the 1920s brought thousands of prospective new residents to Florida. Known as "tin can tourists," they arrived from the "frozen north" in their affordable Model Ts via the newly completed Dixie Highway. (Courtesy collection of the author.)

POSTCARD HISTORY SERIES

Fort Lauderdale

IN VINTAGE POSTCARDS

Susan Gillis

ARCADIA
PUBLISHING

Published by Arcadia Publishing
Charleston, South Carolina

Printed in the United States of America

Library of Congress Catalog Card Number: 2003113820

For all general information contact Arcadia Publishing at:
Telephone 843-853-2070
Fax 843-853-0044
E-mail sales@arcadiapublishing.com
For customer service and orders:
Toll-Free 1-888-313-2665

Visit us on the Internet at www.arcadiapublishing.com

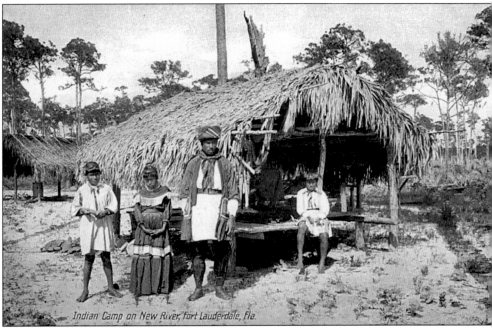

Indian Camp on New River, Fort Lauderdale, Fla.

Although made after 1907, this postcard features a rare, early view of what was once a common Fort Lauderdale scene. Pictured here are the residents of Seminole matriarch Annie Tommie's camp on North Fork of New River, just north of today's Broward Boulevard, c. 1902. The man wears the long shirt and jacket with leggings and a small blanket rolled into a turban, then the height of Seminole fashion. (P2760.)

CONTENTS

ACKNOWLEDGMENTS

The Fort Lauderdale Historical Society, for which I served as curator for many years, is known f
its fine photographic collection documenting the history of the city and surrounding communit
Little known is the substantial collection of local postcards, about 2,000 strong, collected by tł
society since its founding in 1962. This book is my attempt to make available part of that amazin
collection, for the edification and entertainment of the general public. The Fort Lauderdal
Historical Society is grateful to all of the numerous donors who over the years have helpe
preserve local history for the generations to come. I would in turn like to thank the society fo
the opportunity to work with this collection once again and for the always patient cooperatior
of the staff there.

I would also like to thank my friends at the Broward County Historical Commission; Patsy
West, Seminole historian; and Cindy Thuma, fellow Arcadia author, for their contribution and
support of this effort.

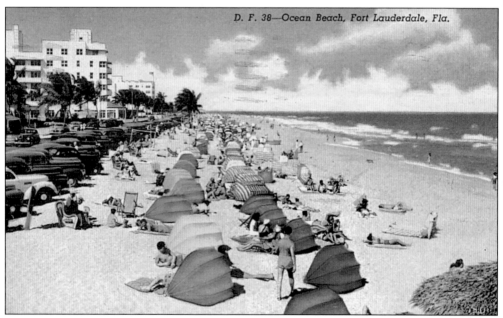

D. F. 38—Ocean Beach, Fort Lauderdale, Fla.

This 1940s scene of the beach north of Las Olas Boulevard captures the classic tourist era in
Fort Lauderdale's history, when much of the community literally closed up shop during the
summer. (P26.)

INTRODUCTION

Fort Lauderdale is recognized throughout the United States as a tourist destination, and the postcard is in fact the perfect metaphor for that phenomenon. The city is named for a Second Seminole War fortification established in 1838 on the beautiful New River in southeastern Florida. Sparsely inhabited throughout the 19th century, the true beginnings of the modern community of Fort Lauderdale can be traced to the establishment of Frank Stranahan's trading post on the river in 1893. In 1896, Henry Flagler's Florida East Coast Railway was completed from Palm Beach to Miami and opened the southeast coast for development. A town began to develop where the rail and river met—the pioneers called it "Fort Lauderdale."

Fort Lauderdale has generated thousands of postal card images throughout its 20th-century history; over 2,000 are housed in the collections of the Fort Lauderdale Historical Society. But not all of these images are of oceanfront hotels and Spring Break crowds. At the dawn of the new century (in the early days of the picture postcard), Fort Lauderdale was touted as the "Gateway to the Everglades," and postcard images featured dredges at work on the North New River Canal, the first of the drainage canals constructed to "reclaim the Everglades." "Downtown" Fort Lauderdale was centered not at the beach, but at the Florida East Coast Railway Tracks and New River. The Seminole Indians, long-time local residents, were also a popular subject in the days before they moved to the reservation in Hollywood. And girls posed with large cabbages—and were clothed from head to toe.

By the 1920s, the Florida land boom was underway and land development and tourism became the mainstays of the local economy. Postcards appeared featuring bathing beauties, Fort Lauderdale's beach, and Mediterranean mansions on idyllic waterways. The end of the boom was signaled by a great natural disaster—the hurricane of 1926, which generated its own souvenir industry, including postcards. Despite hard times, the community was united in its desire for the tourist trade; the first glamorous beach hotels were constructed in this period, and sports fishing became a major attraction. During the 1940s, Fort Lauderdale became an armed camp with the opening of the Fort Lauderdale Naval Air Station, a bomber training base, as well as several other military installations. Travel became difficult because of rationing, and most, but not all, of the visitors to the region were associated with the war effort.

In the years after World War II, Fort Lauderdale experienced growing pains. As thousands of veterans, attracted to the region during their service here, returned with their new families in tow, the city struggled to provide adequate housing and services to the increased population. This phenomenal growth continued during the 1950s and 1960s, with new communities developing to the ever-widening city limits, away from its original core. The "classic" postcards of this era featured "beautiful waterfront homes," "modern architecture," glamorous beachfront hotels, and streamlined mid–century shopping centers. A new theme appeared—postcards featuring Fort Lauderdale's beachfront crowded with young people and identified as "Where the Boys Are," a result of the Spring Break phenomenon memorialized in the 1960 film of that name.

I would like to mention a few technical notes for those interested in postcard collecting. The first "modern" American picture postcards date from early in the 20th century. In 1907, the "divided back" became legal, allowing the message and address to be written on one side, freeing the other for an image. Until the 1940s, postcard images were usually lithographs, either original artwork or created from original photographs. "White borders" were common in the 1920s and 1930s. In the 1930s, the famous "linen" postcard was introduced, which featured a cloth-like finish and muted colors of a tinted photograph. These lasted until after World War II, when the perfection of Kodachrome film resulted in the production of the modern "chrome" style postcard. Throughout all of these eras, true photographic prints have been produced as postcards, although rarer than the mass produced lithographs. Photographs were often printed with postcard mailer backings for the convenience of patrons. They are nonetheless considered postcards.

I have found the "rules" of postcard dating to be only guidelines. The date of the original photograph from which the postcard was made, the date of publication of the card, and the cancellation date (when it was mailed), often differ from each other. In actual fact, manufacturers continued to use the "linen style" into the 1950s, and postcards from 1910 often lack the "white border." I have relied on the date of the images themselves, based on information gleaned from the extensive research archives at the Fort Lauderdale Historical Society and elsewhere, in the assignment of dates to the images in this collection.

The era of 1900–1960s is the focus of *Fort Lauderdale in Vintage Postcards*. This book documents Fort Lauderdale's history as it changed from a riverport, where agriculture was key to the economy, to a world-class tourist destination. It reveals not only the public face of Fort Lauderdale, the beaches, and glamorous locales, but some of the everyday life as well—businesses, downtown scenes, and well-known local landmarks. This postcard history of Fort Lauderdale will prove an entertaining and educational "trip down memory lane" for long-time residents and will give fascinating insight into the complex history and character of one of Florida's largest and best-known cities.

This "large letter" style card represents the typical souvenir postcard of the "linen" era—the vignettes within the letters show the large variety of entertainments available to visitors to Fort Lauderdale in the 1930s, 1940s, and 1950s. (P2270.)

One

1900S–1910S

I had to go to town this morning; a beautiful [town]-- only 3 years old. Plenty work for carpenters. Induce Henry to come. . . . Charles to Josephine in Quintana, Texas, August 1914.

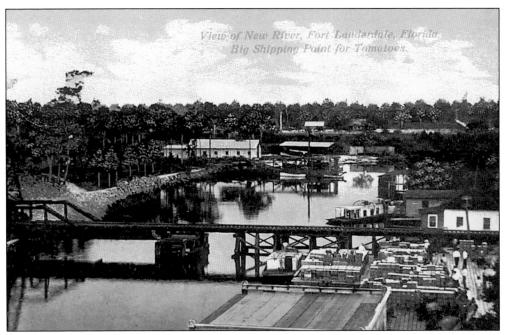

Florida governor N.P. Broward's ambitious Everglades drainage project began with the construction of the North New River Canal in 1906. By 1910, the site where New River and the Florida East Coast Railway meet became the center of the young community, soon known as a key vegetable shipping capital in the South, earning it the epithet "Gateway to the Everglades." (P2754.)

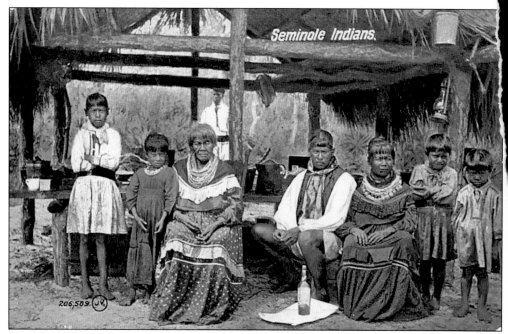

Amongst the earliest "pioneers" of modern Fort Lauderdale were the Seminole Indians, who first arrived in south Florida at the beginning of the 19th century. This image, taken about 1905, shows Annie Jumper Tommie's camp (above, she is fifth from the left), which was established shortly after 1900 on the North Fork of New River near what is today Broward Boulevard, east of I-95. In the 1920s, the family was the first to move to the new Dania (now Hollywood) Reservation. The photo postcard below is a rare 1912 view of the compound. A deer hide is drying on the fence, which is under construction. (P2759 and P2762.)

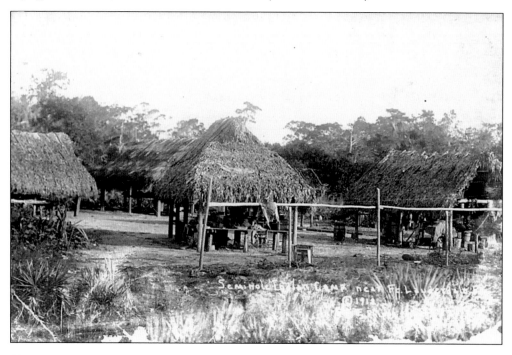

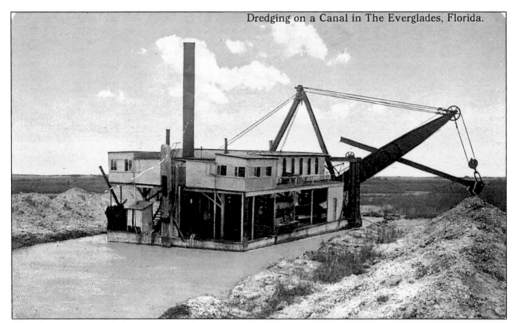

The environment of southern Florida was forever changed with the initiation of Everglades drainage. To modern sensibilities the project seems to have been a terrible intrusion into the state's unique ecosystems, but at the time, it was almost universally embraced in south Florida. Here a dredge makes its way through the sawgrass on its way to Lake Okeechobee, *c.* 1910. (P2756.)

Although ultimately unsuccessful, the Everglades drainage project did open up rich new land for cultivation in areas such as Zona, now Davie, west of Fort Lauderdale. (P519.)

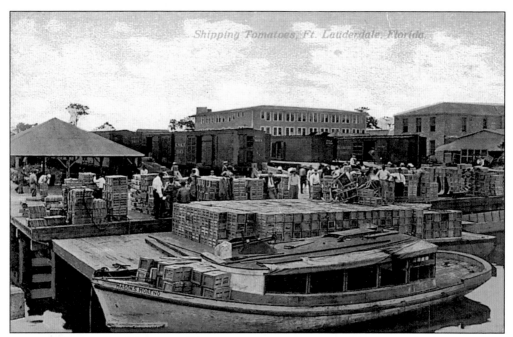

Fort Lauderdale's first "downtown" began to grow up just east of the F.E.C. bridge over New River. This scene shows the everyday bustle near the docks and railway station around 1910. Today this is the site of Riverwalk. (P2753.)

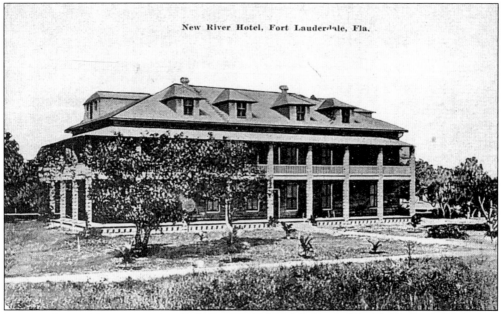

To serve the growing community, Philemon Bryan had this fine new hotel constructed to replace an earlier wooden structure on the site just west of the tracks on New River in 1905. Pioneer contractor Ed King built the hotel using a new material: hollow concrete blocks, now the norm in south Florida. Today the New River Inn is the home of the Old Fort Lauderdale Museum of History. (P2758.)

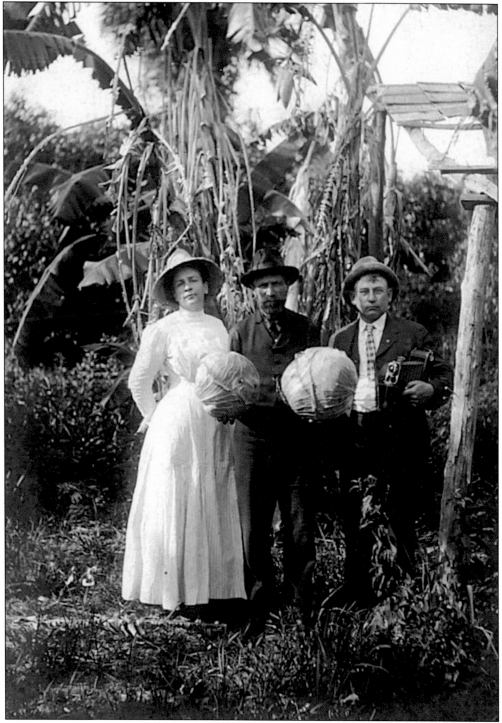

Local farmers experimented with a wide variety of crops in the rich muckland in and around Fort Lauderdale in the early days. In this image, proud locals show off prize-worthy cabbage amidst banana and citrus groves, *c.* 1910–1915. (P83.)

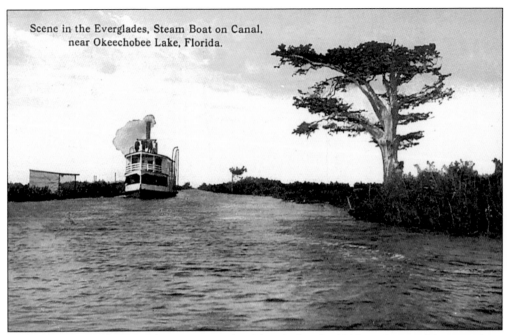

Scene in the Everglades, Steam Boat on Canal,
near Okeechobee Lake, Florida.

The completion of the canal system to Lake Okeechobee in 1915 made travel by steamboat popular in southern Florida. It was possible to journey inland by water from Fort Lauderdale to Fort Myers. (P2742.)

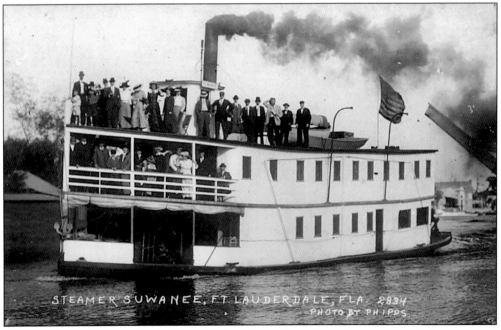

STEAMER SUWANEE, FT. LAUDERDALE, FLA. 2834
PHOTO BY PHIPPS

The steamboat *Suwanee* of the Caloosahatchee River Steamboat Company carried tourists and prospective land buyers through the heart of Florida in 1912. By the 1920s, the canals had become unnavigable due to silting and other maintenance problems. (P58.)

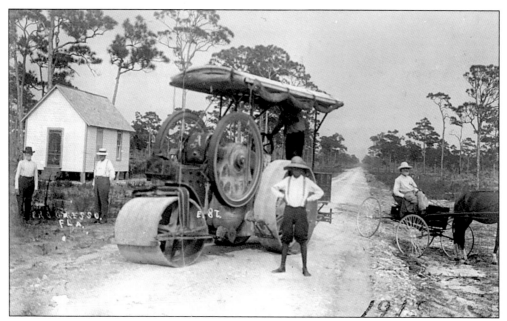

Fort Lauderdale's first "land boom" happened in 1911, when Richard Bolles sold property in the soon-to-be-drained Everglades. With the purchase of each tract of Glades land (some of it still under water today), buyers also received a second lot just north of downtown Fort Lauderdale, in an area dubbed "Progresso." In this photo postcard, road building is underway in 1912. If the note "E Street" refers to E Avenue, this is a view of the future Sunrise Boulevard at about Andrews Avenue. (P518.)

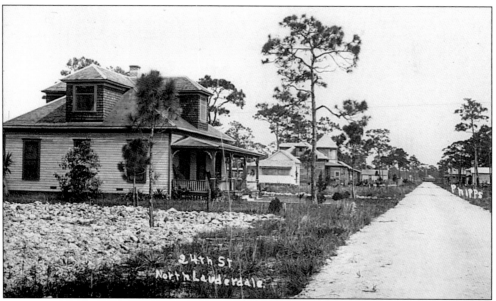

This street scene features new wooden homes on North Andrews Avenue, just north of today's Fifth or Sixth Avenue—the F.E.C. tracks are visible in the background—*c.* 1915. Already, local residents are fighting the natural landscape with introduced species and what looks to be a coral rock yard. (P452.)

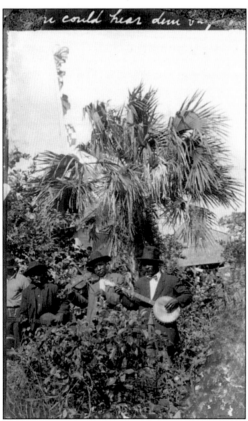

Virtually the entire population of Fort Lauderdale (under 300) showed up for the Christmas Day picnic in 1911. The party was held at one of the few buildings at the beach, the House of Refuge, and featured a fish fry, races, and music. The weather seems to have been brisk, judging by the coats in the crowd. Entertainment and much of the cooking were done by local African-American residents—shown in the rare image at left. (P320 and P15.)

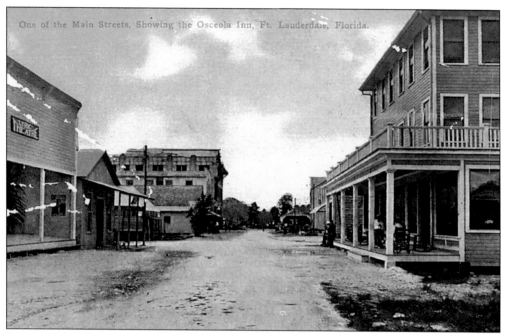

Fort Lauderdale's main street in 1911 was Brickell Avenue, or Southwest First Avenue. This view looking south shows the Osceola Inn at right, the town theatre, the Lyric, and the Wheeler Building under construction in the distance. Today this is the heart of Las Olas Riverfront. (P1166.)

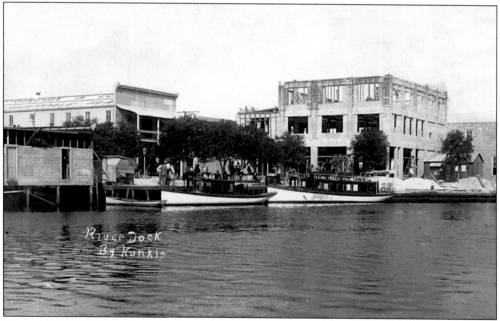

The end of Brickell Avenue, by the river, was obviously prime real estate in 1911. This view taken from the F.E.C. Railway tracks over New River shows the south end of Brickell, now Riverwalk. The tall building at left is Stranahan's Store, and the Wheeler Building is under construction at right, c. 1911. (P1017.)

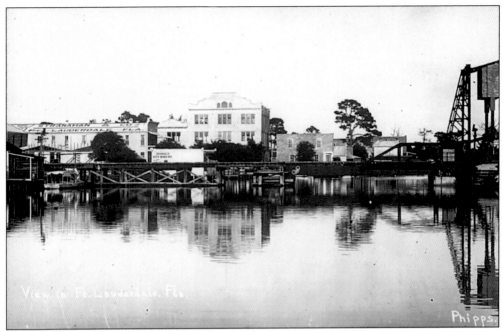

Before the 1920s, most local residents and visitors saw Fort Lauderdale primarily from its waterways. This postcard view looking east features the F.E.C. Railway bridge over New River with Stranahan's Store, the Wheeler Building (still incomplete), and others, probably taken in early 1912. (P1018.)

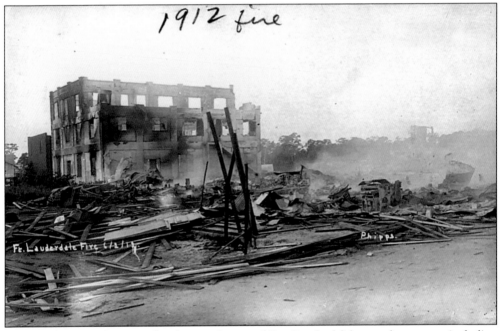

In June of 1912, a disastrous fire destroyed most of Fort Lauderdale's new downtown, including the new Wheeler Building shown here. Fort Lauderdale's fire department was created in response to this tragedy, and the business district was immediately reconstructed. (P283.)

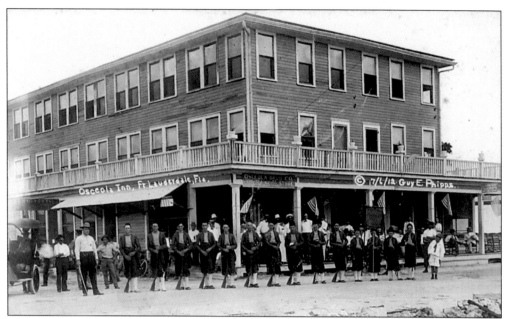

One of the survivors of the 1912 fire was the Osceola Inn, a former warehouse converted to hostelry located on Brickell at the intersection of Wall Street (Sterling Place or West Las Olas). A Miami-based "Zouave" teenage drill team had come to Fort Lauderdale, probably for a patriotic parade. (P397.)

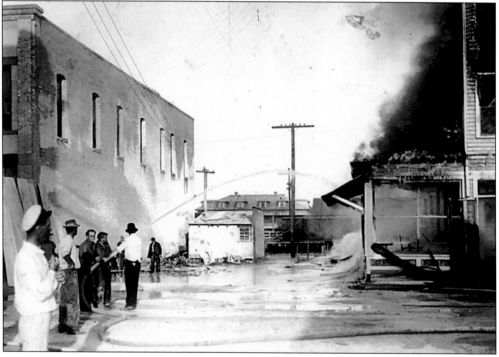

Ironically, even the new fire department could not stop the destruction of the Osceola Inn by fire in 1913. In the distance at center stands the New River Inn. (P286.)

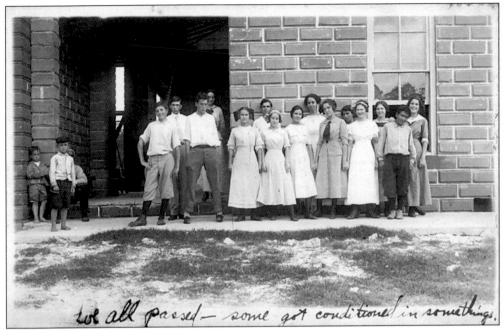

we all passed — some got conditioned in something.

In 1911, Fort Lauderdale's second schoolhouse was built, a concrete block structure on Andrews Avenue and Southwest Fifth Street. The high school students of 1912–1913 are, from left to right, Martin Davis, Prof. H.G. Cummings, Lloyd G. Parker, teacher Miss Margaret Warner, Ruth Alden, Lawrence Rickard, Grace Knapp, Grace Redman, Eleanor King, Joyce Parker, Marie Brock, Eleanor Boyd, Vera High, Dale Redman, and Helen Parker. (P128.)

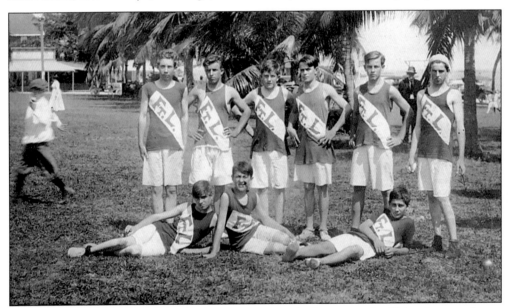

The famed Fort Lauderdale High track team—soon to be known as the Flying Ls—are shown in their younger years at a meet in Miami, *c.* 1913. From left to right are the following: (front row) unidentified, John Davis, and Dale Redman; (back row) Charlie Crim, unidentified, Martin Davis, Watt Gordon, unidentified, and Lloyd Parker. (P1138.)

20

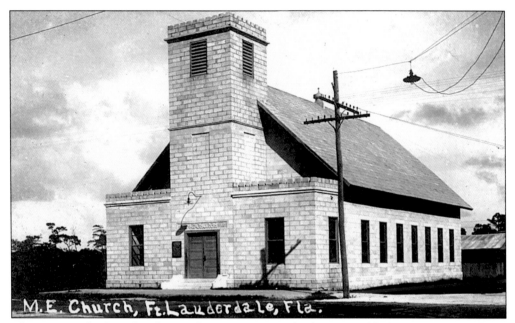

The First Methodist Church, North, was constructed of concrete block in 1913 at Andrews Avenue and Southeast Second Street, where the Main Library is today. The church later became Park Temple, today First United Methodist Church, located just east of the original site, on Southeast Third Avenue. (P1110.)

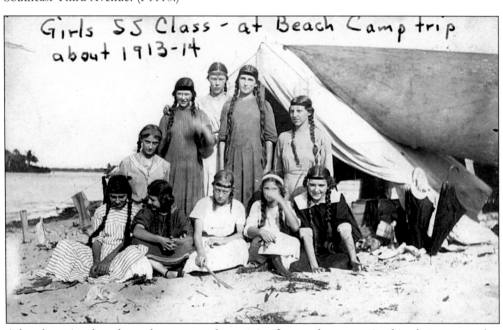

A beach outing has always been a popular activity for youth groups. In this photo postcard, a Sunday School class, dressed in Native American attire, camps out at the beach, c. 1913. They are, from left to right, (front row) Martha Hatfield, Eleanor Boyd, Mae Peterson, Helen Parker, and Bessie Whitmore; (back row) Marie Brock, Grace Knapp, Irene Miller, Ruth Alden, and Joyce Parker. (P1127.)

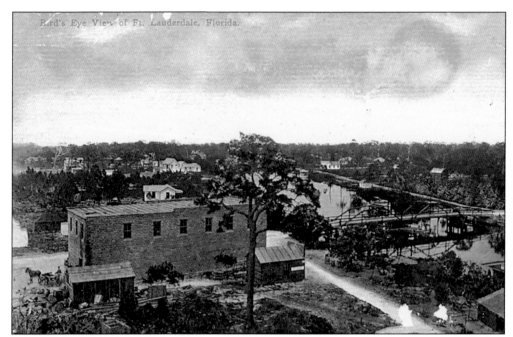

The Andrews Avenue bridge—before Andrews became a major thoroughfare—is featured in this postcard view of New River looking southeast, c. 1912. The masonry building is the Berryhill-Cromartie Store. This rare view reveals the unpaved roads and intact natural landscape of the young town. (P1164.)

An excursion boat passes through the Andrews Avenue bridge in the 1910s. With few roadways and few cars, the river continued to be the most important local highway until the 1920s. (P1013.)

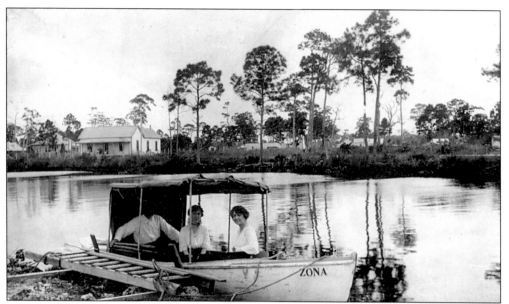

In 1912, expatriate settlers from the Panama Canal Zone and other intrepid pioneers settled in the newly reclaimed mucklands along the South and North New River Canals. They called their community Zona—today the town of Davie. These hardy Everglades pioneers traveled into town for supplies and other needs via the only available route: water. (P1522.)

W.O. Berryhill and B.A. Cromartie opened their grocery store in 1910 on the north side of New River just west of the Andrews Avenue bridge. To the right are small tents, which provided accommodations for the many eager speculators who arrived during Fort Lauderdale's first "land boom." (P86.)

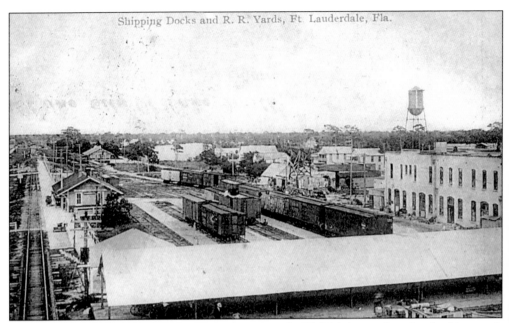

After the 1912 fire, Fort Lauderdale citizens began to rebuild. This interesting view looking north from New River shows the F.E.C. station and sidings and all-important packing shed in the foreground. At the right is the back side of the new Brickell Avenue buildings; to the far right is the two-story Oliver Building shortly after it was constructed in 1913. (P2695.)

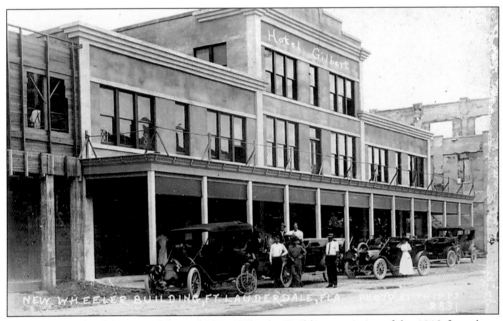

Just to the north of the site of the ambitious Wheeler Building, a victim of the 1912 fire whose shell can be seen at the right of this postcard, a new Wheeler Building was opened in 1913. This was the home of the Hotel Gilbert, a wooden structure that survived until 1959. The Gilbert's meeting rooms also served as a sort of community center, hosting many civic organizations in the second floor hall. Today this is the eastern side of Las Olas Riverfront. (P2696.)

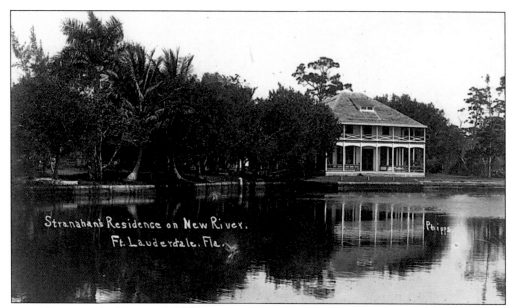

One of Fort Lauderdale's most beautiful homes was that of Frank and Ivy Stranahan, two of the community's founding citizens, shown here in the late 1910s. The house, built on the site of Frank's original trading post, was constructed in 1901 by builder Ed King in the local "cracker" style, facing the river. Today the Stranahan House is open to the public as a restored house museum and occupies a site set back from Las Olas Boulevard above the Kinney Tunnel—amidst the high rises of Fort Lauderdale's downtown. (P425.)

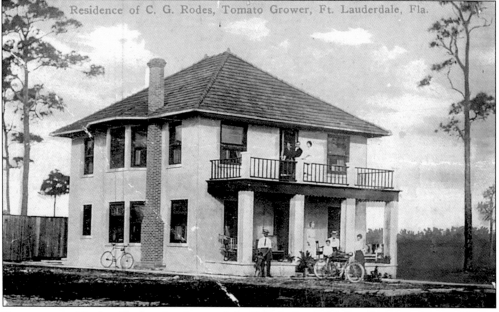

Entrepreneur Charley Rodes, developer of the "Venice" subdivision that brought the "finger-island" technique to Fort Lauderdale, had yet to make his millions when this modest residence was constructed in about 1912. The house stood at 223 Southeast First Avenue and later served as a small hotel. (P438.)

THE OFFICIAL STATE SEAL AND GOVERNOR POST CARD

1904–1908

IN GOD WE TRUST

Hon. NAPOLEON B. BROWARD,
Governor of the State of Florida

COPYRIGHTED 1905, U. S. POST CARD COMPANY
WILMINGTON, DEL.

In 1915, Broward County was carved out of parts of Dade and Palm Beach Counties and named in honor of the late governor who had led the fight to reclaim the Everglades for farmland. The first courthouse was established in the second schoolhouse (recently replaced by the new Central School), located on Andrews Avenue, south of the river at Fifth Street. (P2752 and P313.)

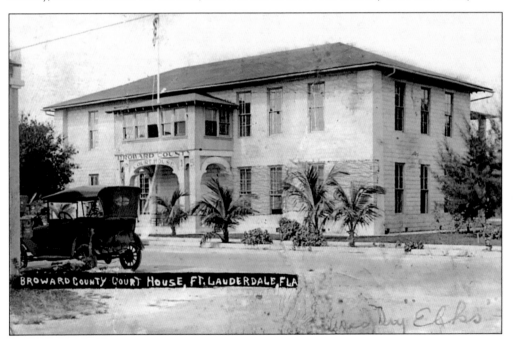

BROWARD COUNTY COURT HOUSE, FT. LAUDERDALE, FLA

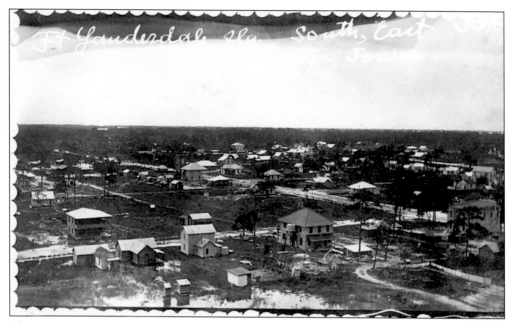

This rare postcard view was taken from the town water tower, looking southeast, *c.* 1915. The water tower was located behind the fire station at what is now Southwest Second Street and Broward Boulevard (the Broward Government Center). The street running diagonally from left to right is Las Olas Boulevard. Note the standing water from a recent storm and the presence of privies—indoor plumbing was still a rarity in town. (P2741.)

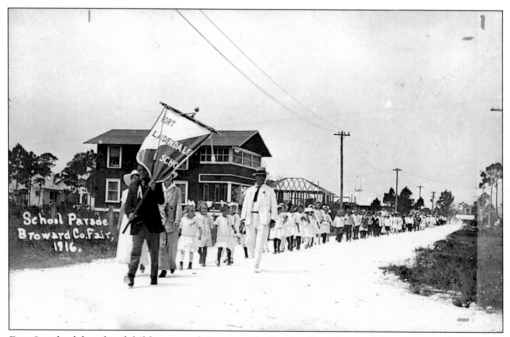

Fort Lauderdale schoolchildren march in a parade for the first Broward County Fair, held at the school grounds (today Southeast Third Avenue south of Broward Boulevard) in 1916. (P127.)

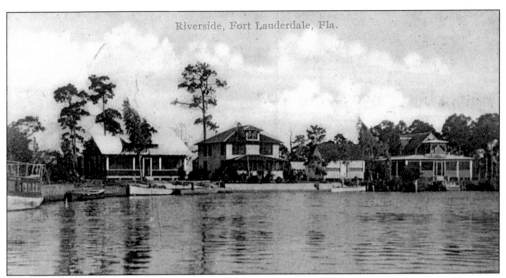

Riverside, Fort Lauderdale, Fla.

One of the first new subdivisions platted after Fort Lauderdale's incorporation in 1911 was Riverside, between the forks of New River. The South Fork, pictured here, was directly on the route to the North New River Canal, hence an important new shipping highway. Nonetheless, astute pioneers like Judge Bunn and D.C. Alexander, who purchased property and constructed these homes *c.* 1915, enjoyed the pristine beauty of the river and countryside removed from downtown. (P241.)

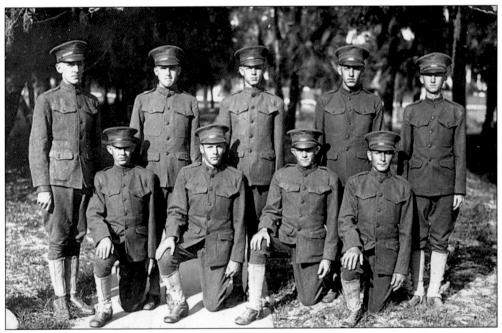

When the nation entered World War I, Fort Lauderdale boys were ready to do their part. The Fort Lauderdale Home Guard is pictured at Fort Screven, Georgia, in 1917 as they prepared for service. They are as follows, from left to right: (front row) Raymond Suchy, Keith Brown, Martin R. Davis, and Dale Redman; (back row) Jennings Howard, Lloyd Parker, James Hendricks, Wade Mahannah, and Ralph Ebner. (P1186.)

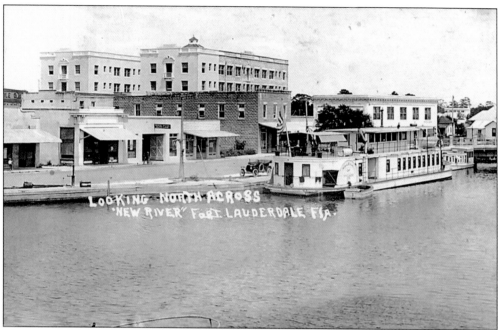

The beautiful Broward Hotel was completed in late 1919, with the assistance of local residents (when the developer ran out of funds). The first guests at the then-unfinished hotel were the crew of D.W. Griffith, in town to make several films. The postcard at top features an interesting view of Northwest New River Drive at the beginning of the boom with the almost completed hotel in the background. The Andrews Avenue bridge is at far right. Below, the newly completed hotel (with bridge at right) stands to the south of Las Olas Boulevard. The directional sign reads: "To Beach, 2 Miles East, Good Road, No Toll." (P1008 and P408.)

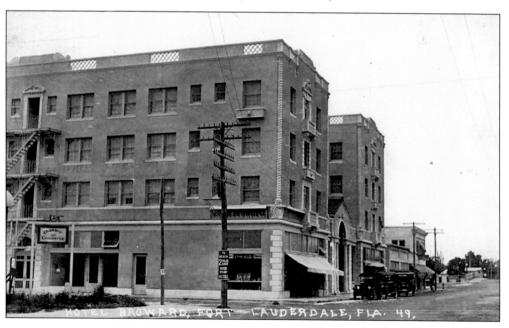

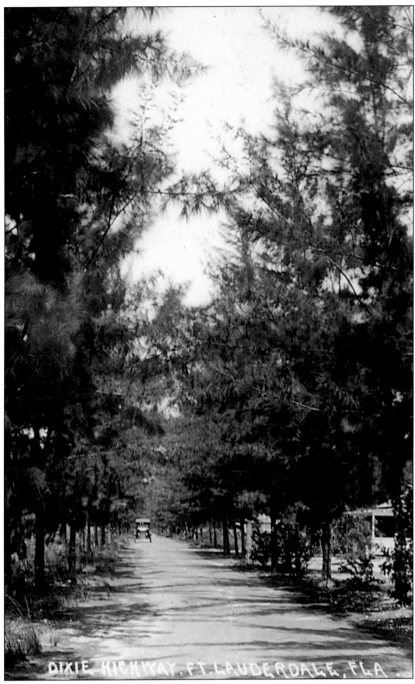

DIXIE HIGHWAY, FT. LAUDERDALE, FLA.

By the end of the 1910s, streets and automobiles had replaced boats and waterways as the principal means of local transportation. Prospective land buyers from the North and Midwest began to make the journey south to take advantage of low land prices and an equable climate. The major automobile route into South Florida was the Dixie Highway—completed through Broward County in 1915. Australian pines were planted as windbreaks along the highway throughout the county. (P1162.)

Two

1920s

Come on out here, this is the place to make some good money; lovely and warm—all the weather like haying all the time. . . . G.K. to Gib in Nobleboro, Maine, December, 1924.

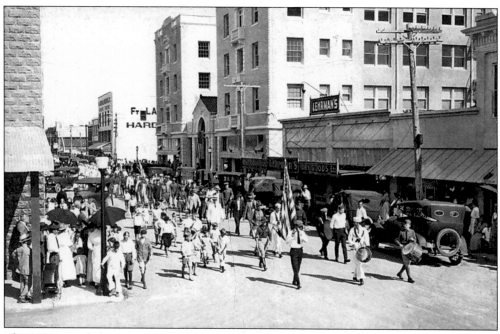

The 1920s signaled an exciting new era for the community, a time still known as the "Boom." Agriculture was "out"; tourism and real estate were "in." By 1920, a new main street emerged in Fort Lauderdale—Andrews Avenue. As the automobile replaced the "pop-boat" as the vehicle of choice, the street with the bridge over New River (and the site of the Dixie Highway through downtown) became the commercial center. This postcard view looking north from the bridge shows a patriotic parade underway in 1920. (P1089.)

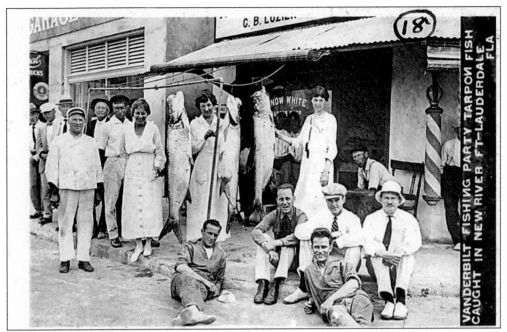

Fort Lauderdale had been known to travelers as a fisherman's paradise since the 19th century. By the early 1920s, when this photo was taken, a charter industry was underway, and the fishing boats and visiting yachts docked besides the Andrews Avenue bridge on Northwest New River Drive, today part of Riverwalk. (P1148.)

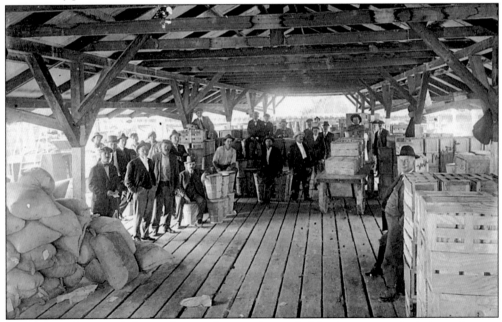

As the 1920s began and the canal system became less navigable, the new tourist industry became the community's financial focus. But agriculture was still an important staple of the economy, and local businessmen pose in the packing shed at the docks by the F.E.C. Railway station in Fort Lauderdale *c.* 1920. (P6.)

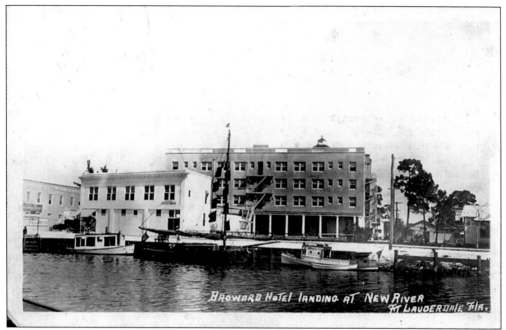

In 1921, local boosters "rescued" President-elect Warren Harding when his yacht was blocked by a barge in what is now the Intracoastal and brought him into town to play a round of golf at the city's new links—located at the site of today's international airport. The city conspirators included Commodore Brook aboard his sailboat *Klyo*, shown docked beside Northeast New River Drive, just east of the Andrews Avenue bridge, above, and with a waving Harding (third from the left) aboard, below. (P406 and P319.)

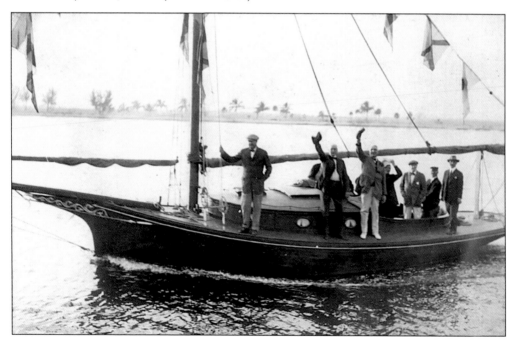

33

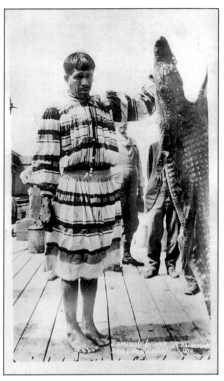

One of Fort Lauderdale's colorful characters was a Seminole named "Shirttail Charlie." Local legend claimed that he had been condemned to wear a dress for the murder of his wife. In fact, he simply wore the "big-shirt" still in vogue with Seminole men. Charlie was a panhandler who frequently posed for photos on the streets of Miami and Fort Lauderdale until his death in 1925. (P463.)

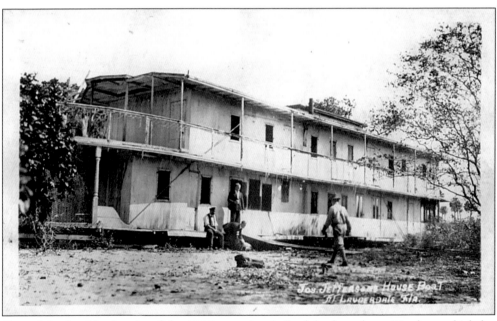

One of the local landmarks of the 1920s was the shell of the houseboat *Wanderer*, which lay rotting at the end of Southwest Fifteenth Street, in the Shady Banks neighborhood, on South Fork. The *Wanderer* had been a luxurious "party boat" owned by naturalist and millionaire C.B. Cory and later actor Joe Jefferson and others. Neglected, it met its final demise in the 1926 hurricane. (P40.)

Long a project dear to the heart of Fort Lauderdale boosters, the development of a port at Lake Mable, a large brackish lake along the Florida East Coast Canal southeast of town, finally got underway in the 1920s. Hollywood developer Joe Young began the development of a "world class port" at the site. When the bust came, the cities of Hollywood and Fort Lauderdale together completed the port, now Port Everglades. (P1096.)

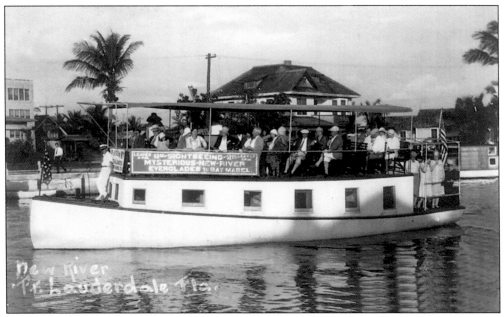

Sightseeing boats have always brought a unique perspective to Fort Lauderdale visitors. Here Captain Otto's boat *Annie Otto* takes prospective land buyers and tourists along the beautiful New River and to the newly opened port at Lake (also known as Bay) Mabel, *c.* 1929. (P2744.)

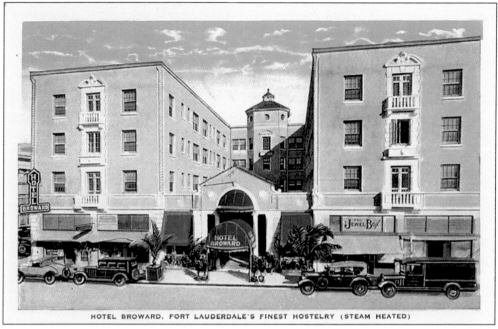

HOTEL BROWARD, FORT LAUDERDALE'S FINEST HOSTELRY (STEAM HEATED)

By now the premier tourist hotel in Fort Lauderdale, the Hotel Broward dominated Andrews Avenue in the late 1920s. These two postcards feature the exterior, above, and an interesting shot of the lobby—complete with "tropical" furnishings and obligatory mounted gamefish. (P2747 and P2459.)

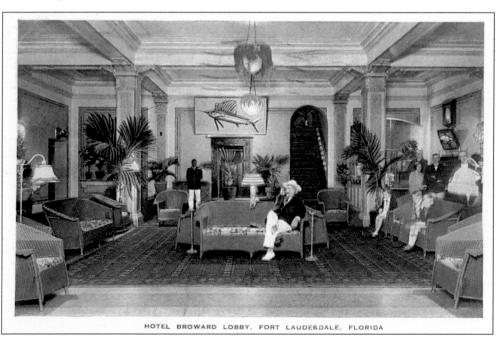

HOTEL BROWARD LOBBY, FORT LAUDERDALE, FLORIDA

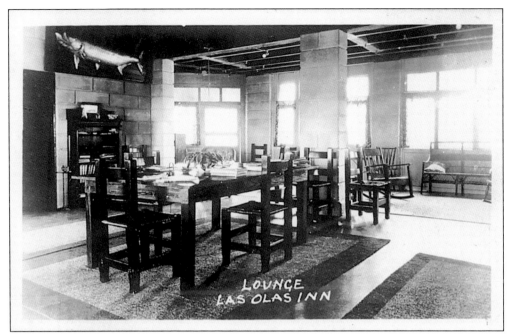

Fort Lauderdale's first hostelry at the beach was the Las Olas Inn, which had been established in the former hunting lodge of Hugh Taylor Birch and John McGregor Adams. In 1902, Ed King constructed the first hollow concrete block structure in town on the site. By the 1920s, it was a tropical oasis for anglers and sun worshipers. Above is a rare look at the rustic interior of the inn, and below, a view of the grounds, *c.* 1925. (P2725 and P417.)

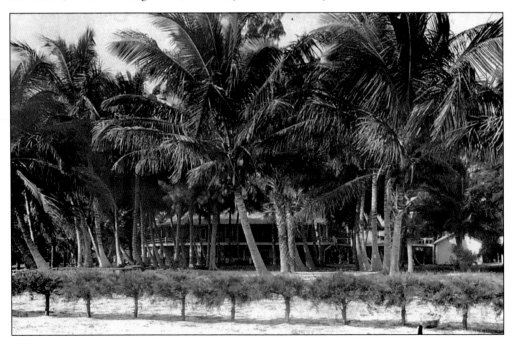

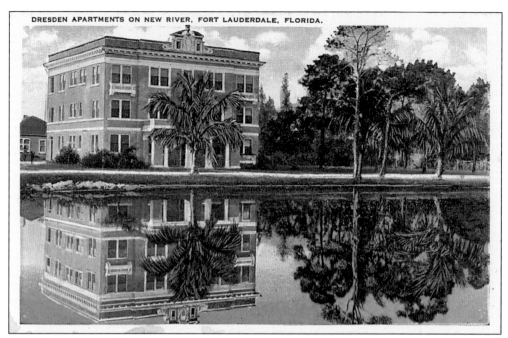

DRESDEN APARTMENTS ON NEW RIVER, FORT LAUDERDALE, FLORIDA.

One of Fort Lauderdale's former riverfront landmarks was the Dresden Apartments, constructed by 1918, and sited at 220 Southeast River Drive on the grounds of today's courthouse. The building declined over the years and was finally demolished in 1967. (P2030.)

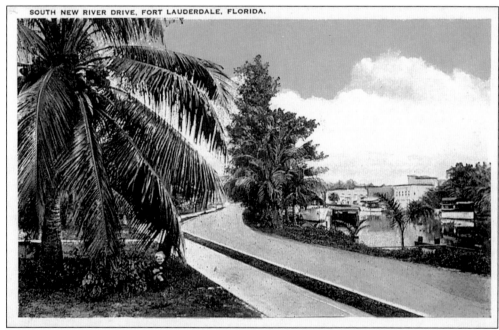

SOUTH NEW RIVER DRIVE, FORT LAUDERDALE, FLORIDA.

This postcard features the view from the front walk at the Dresden Apartments, looking north and west towards the Andrews Avenue bridge and downtown in the early 1920s. Despite the vegetation along the banks, this part of the city was now well developed, complete with paved roads, seawalls, and sidewalks. (P2468.)

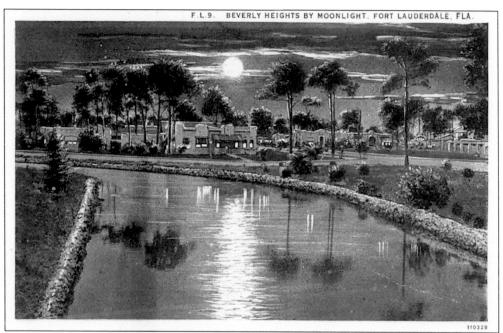

Beverly Heights, located south of Las Olas and north of New River, was a boomtime subdivision that grew up along the Himmarshee Canal. The canal, shown in the postcard, was dredged in the early 1920s and named for the alleged Seminole name for New River, hi-maa-shi, meaning "new" in Mikasuki. (The actual Seminole name for New River was Coontie hatchee—coontie starch river.) The idea intrigued local boosters, and the name is still used today. (P520.)

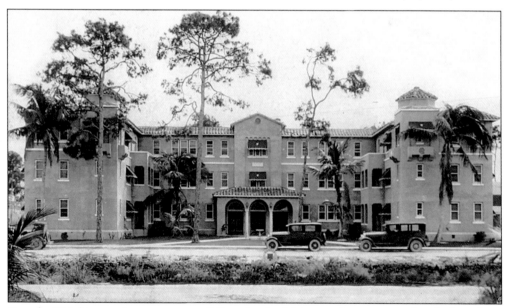

Beverly Heights was home to one of Fort Lauderdale's upscale apartment/hotels for winter visitors: The Towers Apartments. It was designed in the Mediterranean Revival style by local architect Francis Abreu in 1925. The Towers still stands today along the Himmarshee Canal. (P400.)

39

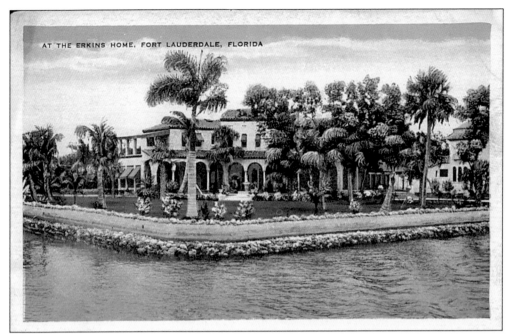

One of New River's showcases in the 1920s was Casa Sonriendo, the beautiful home of Mrs. Ida Erkins designed by Francis Abreu. It featured a "baronial main hall" and cloister-style gallery and was filled with antiques and Mizner Industry reproductions suitable for the Mediterranean style. In 1963 it was demolished to make way for a parking lot. (P433.)

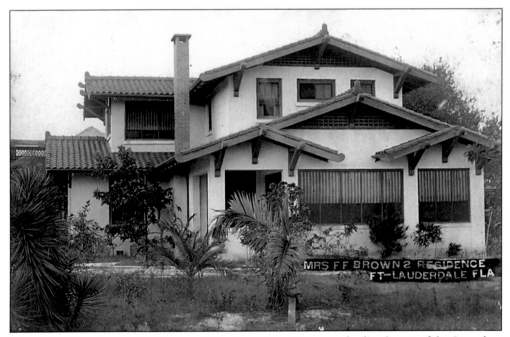

One of Ivy Stranahan's neighbors was Mrs. Fanny Fern Brown, who lived west of the Stranahan Home on North New River Drive. Mrs. Brown's home, constructed in the Craftsman style, reflects Oriental influences, which were still popular in the 1920s. (P442.)

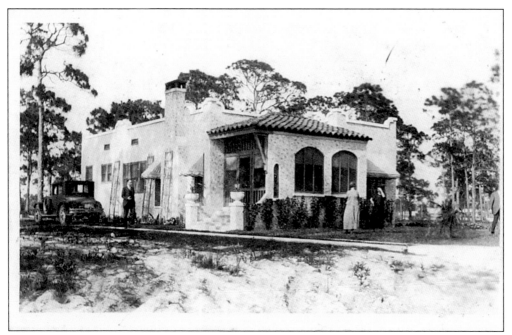

By the mid-1920s, the Florida land boom was underway and thousands of new residents poured into Fort Lauderdale. New subdivisions were developed and homes built, many in the popular Mediterranean style. This modest home, which stood on Southeast Fourth Street, was that of John Needham, owner of the Broward Hotel, and his family, shown in a *c.* 1924 postcard. By 1926 they had a glamorous, larger residence on the river. (P429.)

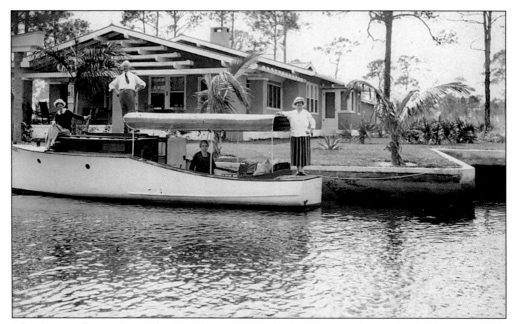

Like the Needhams, Mr. and Mrs. E.N. Sperry made the move to a larger, fancier home in 1926. Their charming first home on the river featured Japanese-influenced Craftsman details, in *c.* 1923. The house still stands, although greatly modified, on North Rio Vista Boulevard. (P444.)

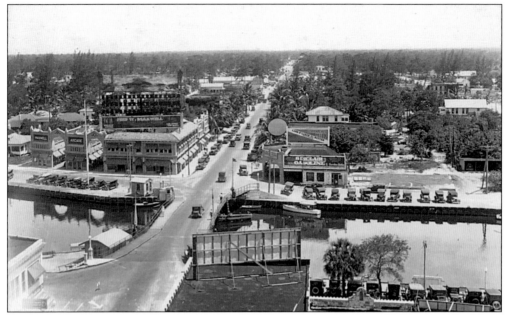

In a few short years, Fort Lauderdale experienced tremendous growth and wealth as a community as a result of the land boom. This view, taken in late 1925, shows Andrews Avenue south of New River, looking down towards the Croissant Park development to the south. (P304.)

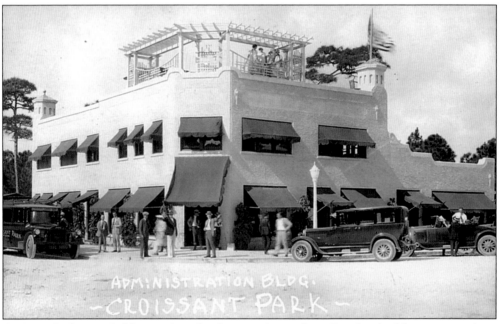

Croissant Park, a typical boom time development in southern Fort Lauderdale, grew up along Andrews Avenue south of Davie Boulevard in the mid-1920s. The sales office was in the *c.* 1923 Administration Building. originally built for a previous development, Placidena. It has been beautifully restored and still stands on South Andrews today. (P517.)

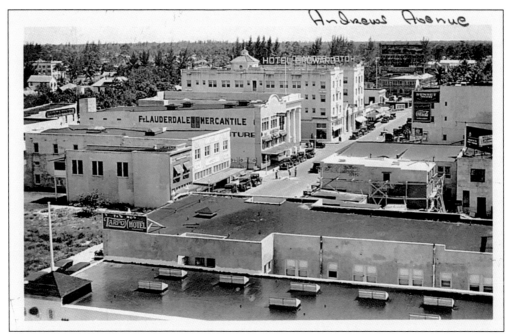

Andrews Avenue was still in the midst of boom time development in 1925 when this postcard was made. The view is looking south from Southwest Second Street and a number of lots have yet to be built upon. The photographer is shooting from atop the Bryan Arcade. (P1172.)

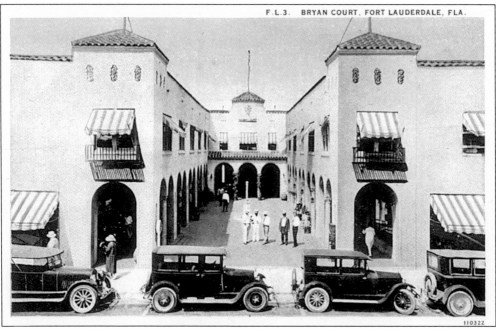

Another of architect Francis Abreu's projects, the Bryan Arcade opened at the southwest corner of Andrews and Southwest Second Street in 1925. Abreu's office was in the "court," as were many important downtown businesses and Brown's Restaurant. Although completely remodeled, the building still stands today. (P2452.)

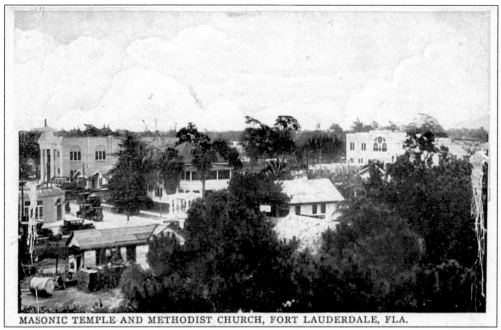

MASONIC TEMPLE AND METHODIST CHURCH, FORT LAUDERDALE, FLA.

Downtown redevelopment, which began in the 1970s, dramatically changed downtown vistas. This postcard features a rare view from just east of Andrews Avenue and north of Southeast Second Street, *c.* 1925. At left stands the Masonic Temple on Southeast First Avenue, and to the right is Park Temple Methodist Church (which still stands). Most of the area in the foreground is today occupied by the Main Library. (P2456.)

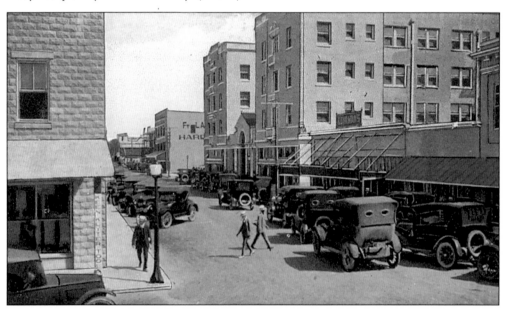

In 1920, Andrews Avenue was already a busy main street, the southern end anchored by the new Broward Hotel. This postcard view was taken from New River Drive looking north. Notice the brick building to the north of the hotel, at the center of the picture, which is Fort Lauderdale Hardware. (P2523.)

By June of 1926, the First National Bank opened in Fort Lauderdale's first "skyscraper," the nine-story structure later known as the Sweet Building. The building was "the place" for one's office, and the sign on the first floor is the office of the Mizner Development Corporation's Boca Raton sales office. The Sweet Building changed the skyline and gave photographers a new "height" from which to document downtown. (P2510.)

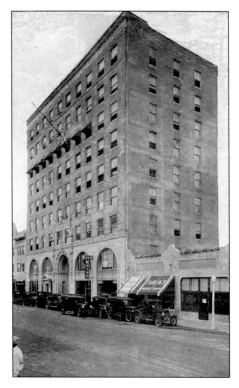

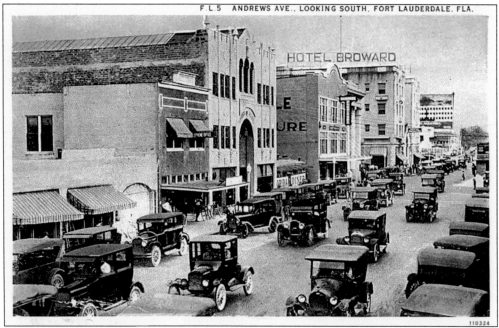

By mid-1926, the empty lots on South Andrews Avenue had been filled with new structures. The new Tropical Arcade is open, shown at center (with the pointed gable), and Fort Lauderdale Hardware, to the right, has a fine, new curvilinear gable-façade. Note the traffic, so familiar to modern residents. (P1171.)

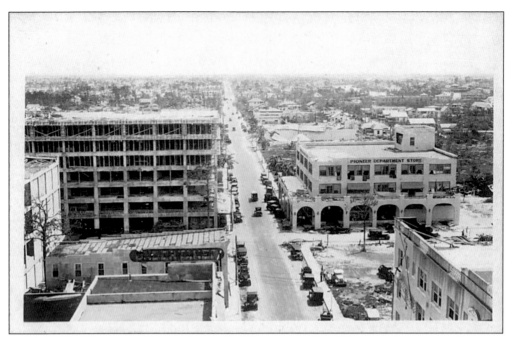

On September 18, 1926, a terrible hurricane hit South Florida, striking a final blow to the already dying land boom. Hundreds died and thousands were left homeless as the area was sunk into economic depression years ahead of the rest of the nation. These two spectacular postcard views were taken from atop the brand new Sweet Building. Above is the view looking east on Las Olas Boulevard—the Pioneer Department Store is at right and the never-finished WilMar Hotel is at left, today the site of the new Florida Atlantic University tower. Below, a look north on Andrews from Las Olas reveals the terrific damage done to roofs. The new Tropical Arcade is in the far right corner. (P421 and P1233.)

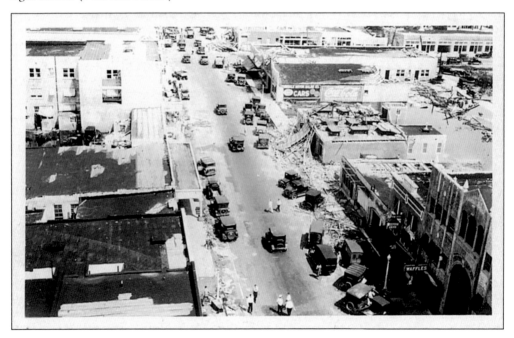

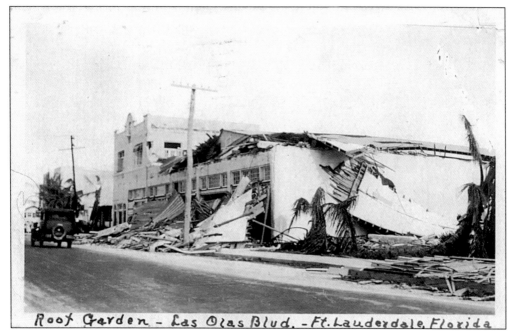

Roof Garden - Las Olas Blvd. - Ft. Lauderdale, Florida

On September 17, 1926, a group of Jewish residents gathered to meet and hold services on the second floor of the Roof Garden Restaurant on East Las Olas. They left that evening, happy that they finally had a home for their congregation. Within hours their new home was destroyed, and the building of a local temple was not completed until 1937. (P1204.)

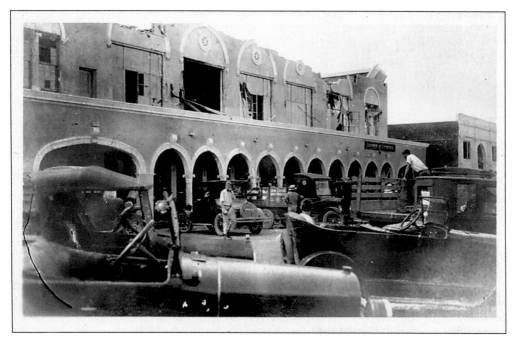

Fort Lauderdale's beautiful City Hall, designed by architect John Peterman, was heavily damaged by the 1926 storm. City Hall was then located on the west side of South Andrews Avenue in the 100 block, where the Government Center stands today. (P1211.)

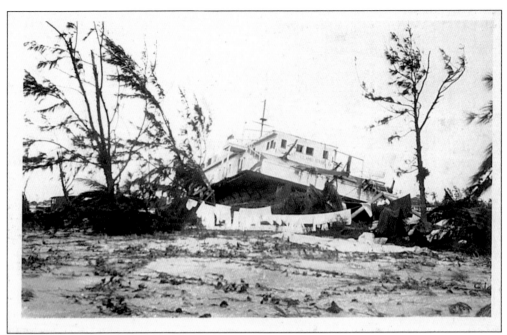

Another victim of the 1926 storm was the U.S. Coast Guard's houseboat, *Moccasin*, housed near today's Bahia Mar. The guardsmen's water-logged wardrobe hanging on the line is a poignant reminder that "life goes on." (P2790.)

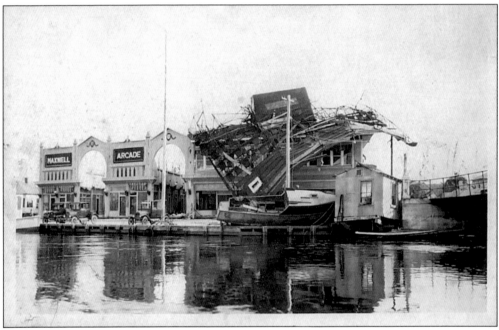

In 1925 Fred Maxwell opened the Maxwell Arcade, featuring an elaborate electric-lighted sign built at the reputed cost of $150,000—an extravagant expense even in those days. The sign and much of the building were destroyed on September 18, 1926; however, the Maxwell Arcade survived and is today the home of the Downtowner Saloon. (P1209.)

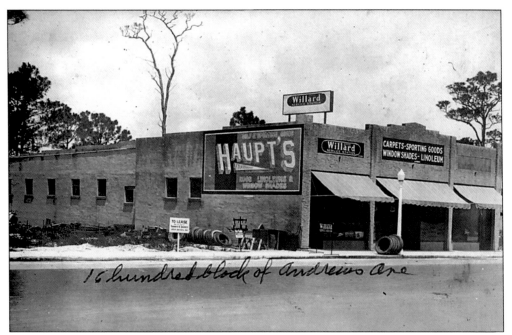

Above and below are two postcard views of the same structure, before and after September 18, 1926. Haupt's, which offered carpeting, golf, and sporting goods, was located at the 1600 block of South Andrews Avenue in the new Croissant Park neighborhood, near today's Broward General Hospital. The same building is shown below, a complete ruin. A small portion of the painted sign—a "pennant" with the words "Ft Lauderdale"—can be seen in the ruins to the right of the store. (P89 and P1215.)

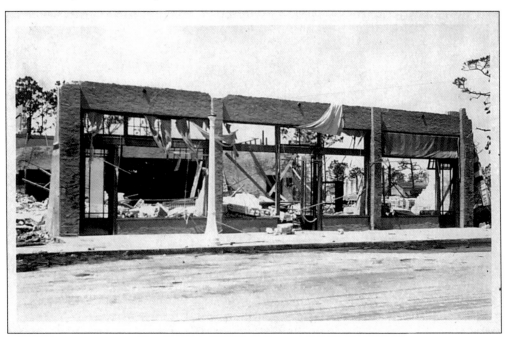

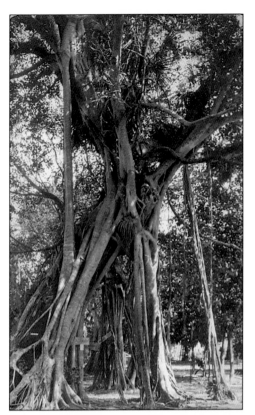

In 1920, Commodore A.H. Brook opened a tropical attraction dubbed Wyldewood Park just south and east of today's Fort Lauderdale/Hollywood Airport. A fairly young banyan tree, then a local rarity, was allegedly visited by James Deering, owner of Vizcaya. A friend commented that it would cost $1 million to move the tree to his Biscayne Bay estate, whereupon Deering proclaimed it would cost $2 million. From then on, a sign declared the "$2,000,000" tree. In 1929, the commodore's sister opened a tea room beneath the branches of the tree. At left is a postcard of the popular tree, and below, a rare glimpse of the tea room interior. (P2745 and P88.)

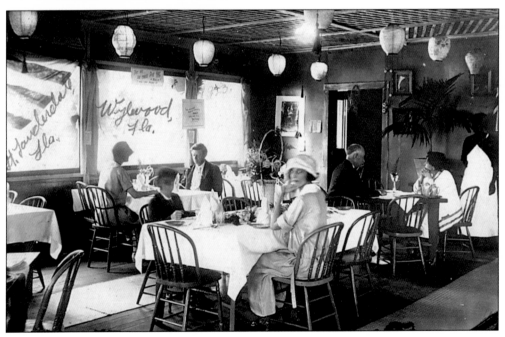

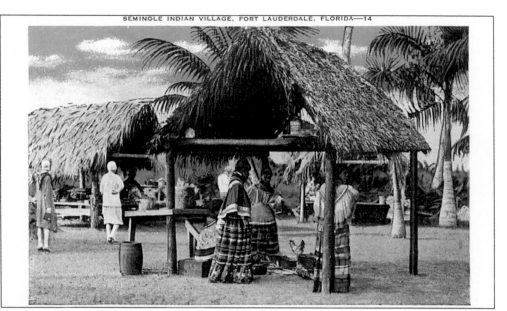

By the late 1920s, the Seminole inhabitants of Fort Lauderdale had largely left for the new reservation or the growing Seminole tourist attractions in Miami. Local entrepreneur Bert Lasher opened a small Seminole village attraction in Fort Lauderdale on the North Fork, near the Eleventh Avenue bridge, in the 1920s. Here visitors stroll the camp while Seminole women tend the cooking chickee. (P458.)

F.L. 15 WEST SIDE COUNTRY CLUB HOUSE, FORT LAUDERDALE, FLA.

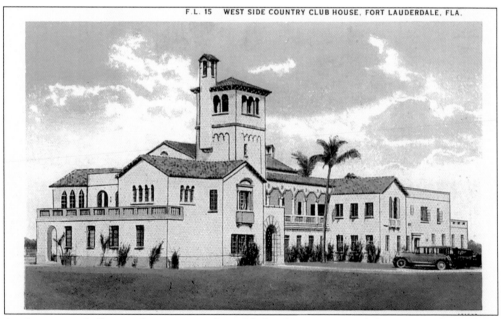

Anxious to capitalize on the new rage for golf, the City constructed the West Side Golf and Country Club in 1926 on West Broward Boulevard in what is today Plantation—the wilderness in its time. Designed by architect Francis Abreu, the building served as a setting for society occasions as well as sports activities. In 1957 the club became the private Fort Lauderdale Country Club, and the old building succumbed to damage and time in 1982. (P1128.)

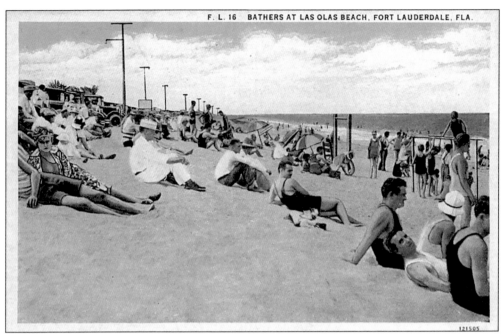

By the 1920s, the beach, once of little importance to local residents, became the focus for the new tourist industry. The main part of the public beach was at Las Olas and A1A, as it is still today, and was referred to as "Las Olas Beach." Above, bathers lounge on the beach, where parking was free, and below, children frolic on the scary-looking diving tower just offshore. (P1994 and P2507.)

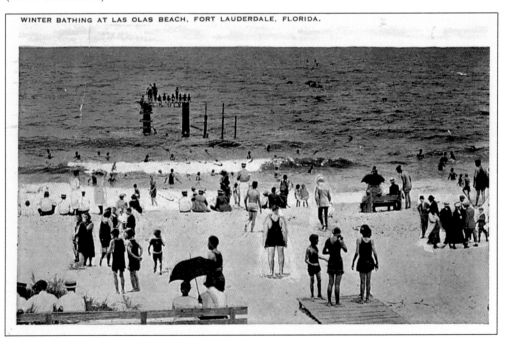

WINTER BATHING AT LAS OLAS BEACH, FORT LAUDERDALE, FLORIDA.

Three

1930s

I tried to get a view of one of the bridges I told you there were so many of—and they cost $11,000 a piece and when they were put in they spent $25 million dollars on the bridges and canals. . . . to Minnie, c. 1930.

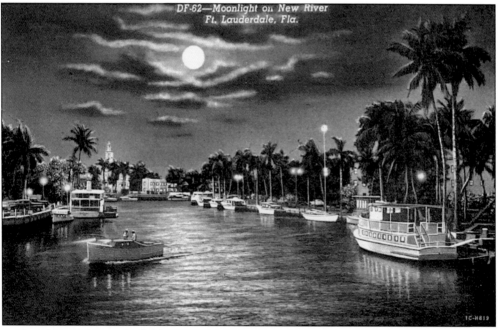

DF-62—Moonlight on New River
Ft. Lauderdale, Fla.

In the 1930s, Fort Lauderdale's citizens suffered, like others in the nation, from the effects of the Great Depression. But the city's saving grace and great hope was its wonderful climate and beauty, always a tourist draw. By the 1930s, Fort Lauderdale was well on the way to becoming a boating capital, with its miles of waterways and tropical scenery. What was once a working river became known as one of the young town's most beautiful attractions, which it remains today. (P995.)

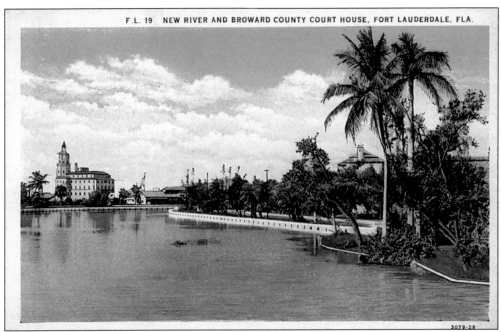

Above, the Broward County Courthouse, opened in 1928, is the landmark in this scene on New River looking west from just west of the Federal Highway bridge taken early in the 1930s. Below, by the late 1930s, the empty seawalls are now lined with boats, and the maturing landscape has obscured most of the courthouse. (P2522 and P2791.)

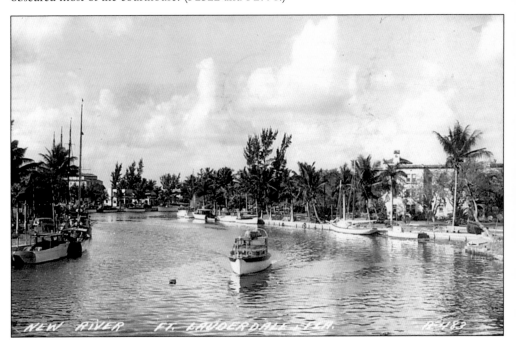

54

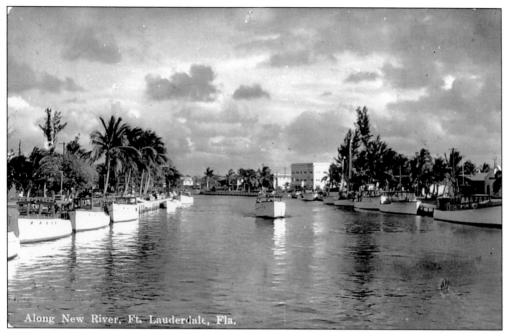

This mid-1930s view shows New River looking east from Andrews Avenue. In the center ground is the Dresden Apartments. Today the Third Avenue bridge spans the river just beyond the site of the apartments. (P999.)

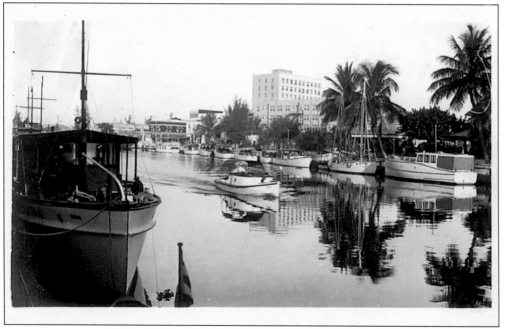

Private boats and charters gathered near the Andrews Avenue bridge along North New River Drive in the 1930s. In the background towers the Sweet Building and downtown Fort Lauderdale. (P1014.)

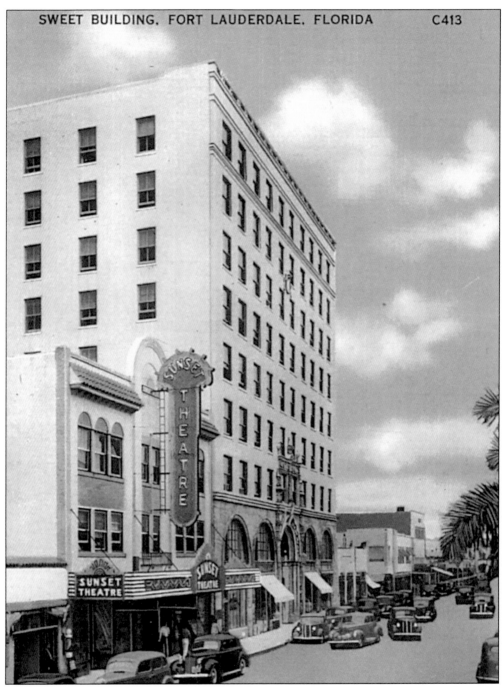

In 1927 Fort Lauderdale's first skyscraper, the First National Bank Building, was purchased by William L. Sweet Jr. The Sweet Building, a survivor of the 1926 storm (and many after), is still a prestigious address for local businesses, outlasting the decline of downtown and consequent downtown redevelopment. Renovated in the 1980s, the building lives on as a part of One River Plaza. This postcard view features a scene looking north towards the Sweet Building and its neighbors in the late 1930s. (P1999.)

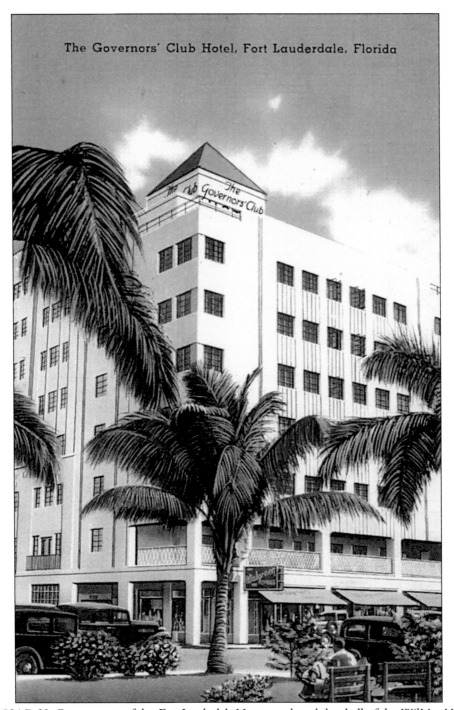

The Governors' Club Hotel, Fort Lauderdale, Florida

In 1934 R.H. Gore, owner of the *Fort Lauderdale News*, purchased the shell of the WilMar Hotel, a victim of the collapse of the land boom, located on East Las Olas Boulevard. In 1936 it opened as the Governor's Club Hotel, catering to tourists and business travelers. Over the years it played host to many conventions, banquets, and meetings in its ballroom. It closed in 1976 and was finally demolished in 1995, making way for the new FAU/BCC Tower. (P2281.)

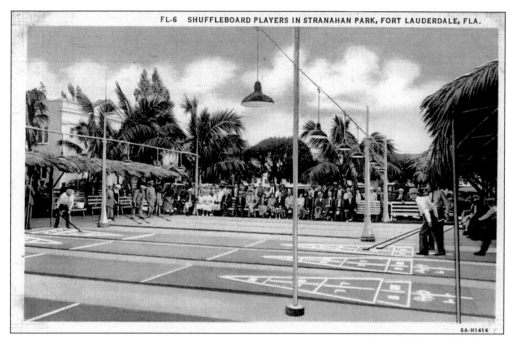

FL-6 SHUFFLEBOARD PLAYERS IN STRANAHAN PARK, FORT LAUDERDALE, FLA.

In the 1930s, shuffleboard became a very popular local sport, particularly with winter visitors. Fort Lauderdale's main courts were located in Stranahan Park, where the Main Library stands today. In the 1930s, the Fort Lauderdale Shuffleboard Club brought together people from all over the United States and Canada and featured a large female membership. Many of the snowbird members were convinced to become permanent residents of the community. (P2042.)

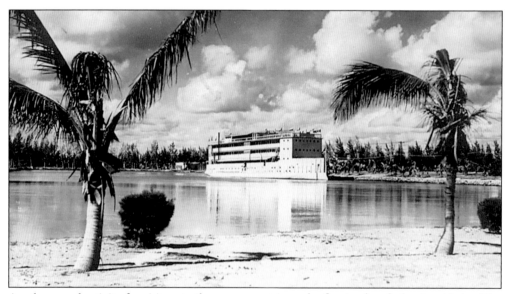

Another novel activity for visitors to the area was a trip to the floating hotel, the Amphitrite. The hotel was a converted monitor class ship that arrived in 1931 and moored near the Coast Guard Station (today Bahia Mar). The hurricane of 1935 forced it onto the shores of Idlewyld, across the Intracoastal, where it is pictured in this postcard. It was soon relocated to the island in the center of the Las Olas Causeway. (P2750.)

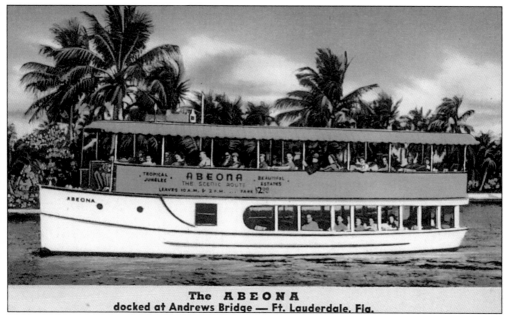

The ABEONA
docked at Andrews Bridge — Ft. Lauderdale, Fla.

The *Abeona* sight-seeing boat was commonly seen on the water in and around Fort Lauderdale from the 1930s until the 1960s. A cruise aboard the *Abeona* exposed visitors to beautiful riverfront homes, local landmarks, and not a few local "legends." The *Abeona* made her home on the docks of North New River Drive. (P1577.)

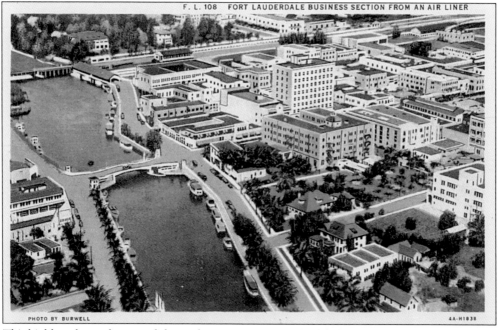

This highly enhanced postcard shows downtown Fort Lauderdale looking west in the early 1930s. North and South New River Drives can clearly be seen as viable thoroughfares in the image. After the construction of the 1979 high-span Andrews Avenue bridge, the roads were for the most part abandoned. Today they form much of Riverwalk. (P294.)

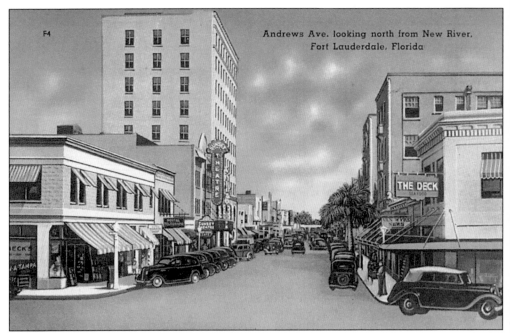

Andrews Avenue remained little changed from the previous decade in the 1930s, as seen in this view above, looking north from the bridge. In 1937 "Skipper" Fred Beck opened a popular bar called The Deck, in the *c.* 1913 Witham Building, to the south of the Broward Hotel. The Deck featured live entertainment and played host to many servicemen during the war years, closing in 1948. (P1169 and P2786.)

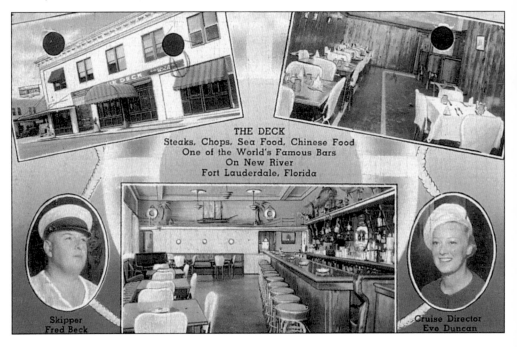

THE DECK
Steaks, Chops, Sea Food, Chinese Food
One of the World's Famous Bars
On New River
Fort Lauderdale, Florida

Skipper
Fred Beck

Cruise Director
Eve Duncan

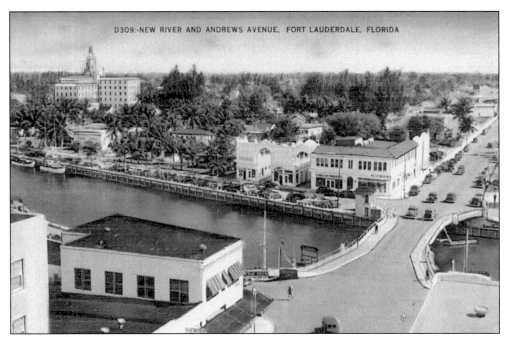

The Maxwell Arcade, minus its famous sign, can be seen at the center of this postcard view looking south along Andrews Avenue in the late 1930s. The rear of the Broward County Courthouse is visible at left. (P2704.)

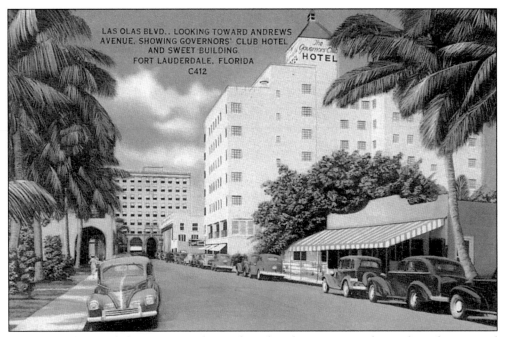

"Downtown" extended east on Las Olas Boulevard in the 1930s, as it does today. This postcard features the view looking west towards Andrews Avenue from about Southeast Third Avenue, late in the decade. The Governor's Club is shown at the right, and the empty building that formerly housed the Pioneer Department store is the arcade at left. (P1745.)

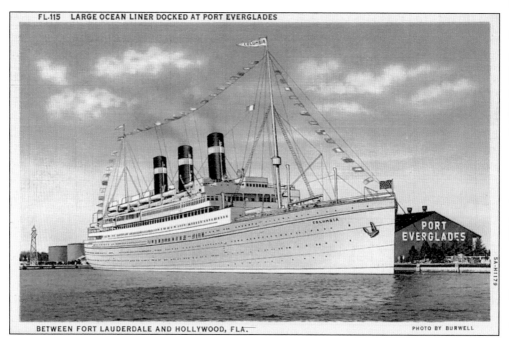

FL-115 LARGE OCEAN LINER DOCKED AT PORT EVERGLADES

BETWEEN FORT LAUDERDALE AND HOLLYWOOD, FLA. PHOTO BY BURWELL

The arrival of the S.S. *Columbia*, shown above, the first cruise ship to enter Port Everglades, marked the maturing of the new port and a boon to the local economy. On January 18, 1932, Capt. John Jeuseue was greeted by local ladies with flowers and a fruit basket, below. (P2415 and P1108.)

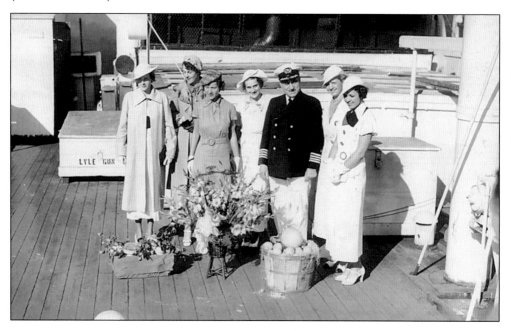

6A-H2649

By the end of the land boom, the development of the islands off Las Olas Boulevard had largely halted due to the economic downturn. In 1927, the road to the beach was renovated by the city and dedicated to the soldiers of World War I as Memorial Boulevard. A row of royal palms graced the median and landscaping was put in along the swales on either side of the road. These two postcard views reflect the then-sparsely inhabited causeway in the 1930s. (P2428 & P2433.)

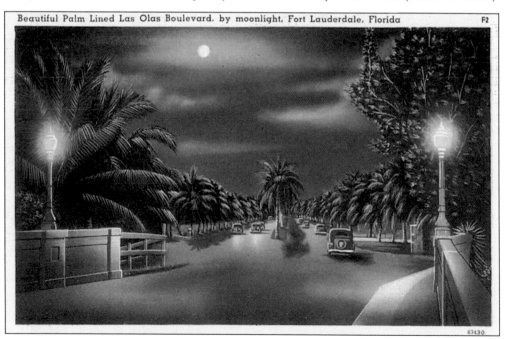

Beautiful Palm Lined Las Olas Boulevard. by moonlight, Fort Lauderdale, Florida F2

67430

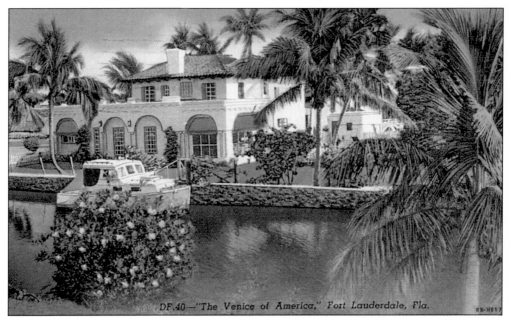

DF.40—"The Venice of America," Fort Lauderdale, Fla.

Waterways are a recurring popular theme for Fort Lauderdale postcards. This late 1930s view features the Quinn House, built in the Mediterranean style in the mid-1920s and sited just inside the entrance to the Himmarshee Canal, off New River, where it still stands. The postcard is one of the earliest to feature the now popular epithet "Venice of America." (P450.)

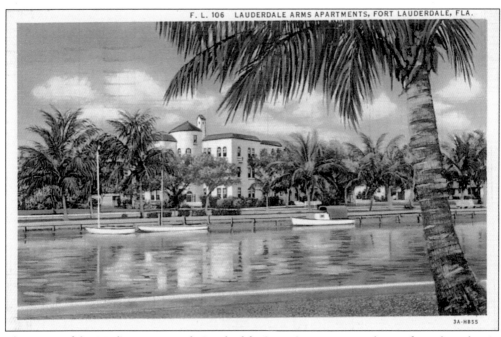

F. L. 106 LAUDERDALE ARMS APARTMENTS, FORT LAUDERDALE, FLA.

The tower of the Mediterranean-style Lauderdale Arms Apartments peeks out from the palms in this 1930s river view. The Arms was designed by architect Francis Abreu in 1925 and was located on the north side of New River west of the Federal Highway bridge. The apartments were demolished in the 1970s. (P2749.)

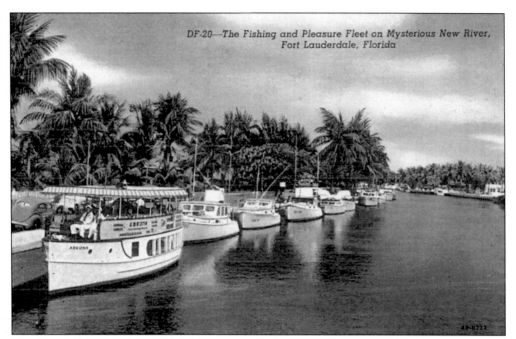

DF-20—*The Fishing and Pleasure Fleet on Mysterious New River,*
Fort Lauderdale, Florida

Above, small craft and charter boats (including the *Abeona*) lined North New River Drive just east of the Andrews Avenue bridge late in the 1930s. Below, a view of South New River Drive looking west reveals the beautiful and ubiquitous coconut palms that once defined Fort Lauderdale's scenic vistas before they succumbed to disease in the 1970s. (P1021 and P1443.)

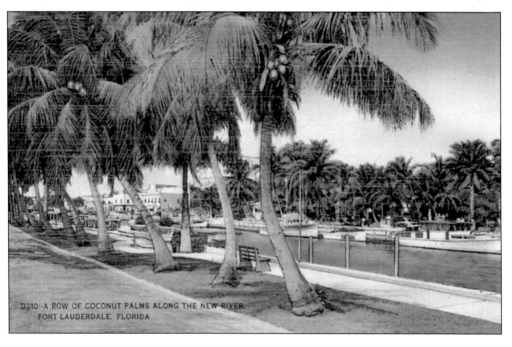

D310:-A ROW OF COCONUT PALMS ALONG THE NEW RIVER.
FORT LAUDERDALE. FLORIDA

The Ocean Vista cottages stood at 401 South Atlantic Boulevard (A1A) from the 1930s until the 1970s. These modest accommodations reflect the smaller, inexpensive hostelries once common along Fort Lauderdale Beach. (P16.)

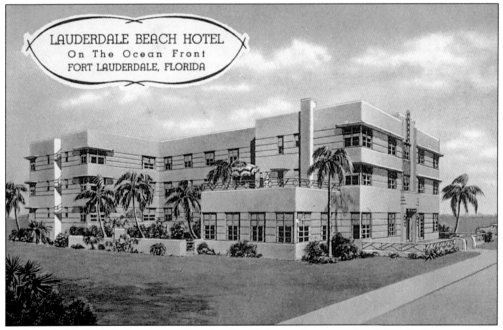

LAUDERDALE BEACH HOTEL
On The Ocean Front
FORT LAUDERDALE, FLORIDA

At the other end of the beach was Fort Lauderdale's premier example of the Moderne style, the Lauderdale Beach Hotel. Constructed in 1937, it was within a few years enlarged and reigned as queen of the beach for many years. This postcard features a rare side view of the hotel at its original height. (P114.)

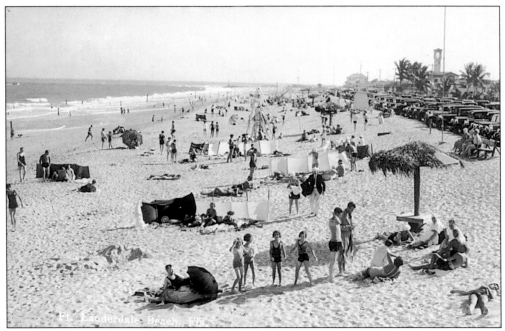

Las Olas Beach remained a popular tourist destination even during Depression years. This is a view of the beach looking south from Las Olas Boulevard; the tower of the Casino Pool is visible at right. This "chamber of commerce" picture appeared in the newspaper in 1934. (P17.)

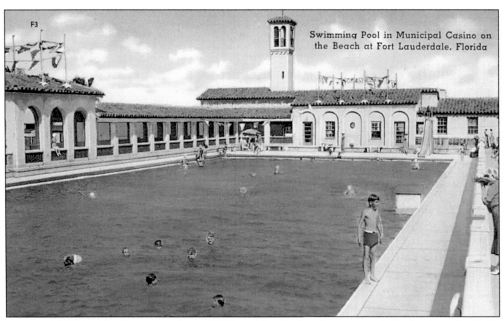

Designed by Francis Abreu, the beautiful Las Olas Casino Pool opened for business in 1928. It was a saltwater pool—ocean water was exchanged daily—and quickly became the scene of national and international natatorial competitions. In 1935, the first Annual Collegiate Swim Forum was held here, bringing college students to the area in a phenomenon some hail as the origins of Spring Break. (P1302.)

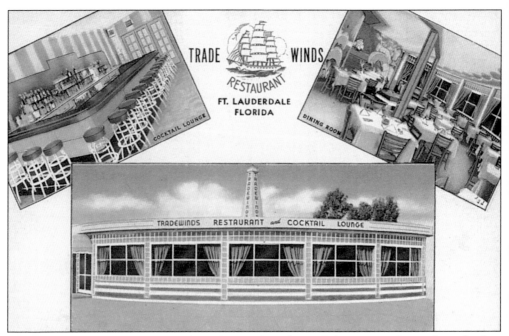

The very Moderne-style restaurant Trade Winds welcomed downtown diners from the late 1930s until the late 1940s. It stood at 201 Southeast First Avenue, across from the main post office. (P2264.)

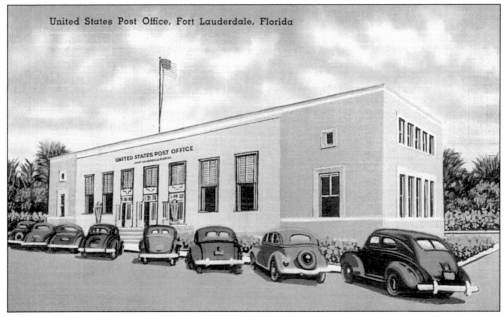

Fort Lauderdale's main post office in the mid-20th century stood on Southeast First Avenue, where the city parking garage and college lots are today. The structure was built by the Works Progress Administration in 1936 and drew businesses and eateries to First Avenue. The building was demolished in 1974. (P2280.)

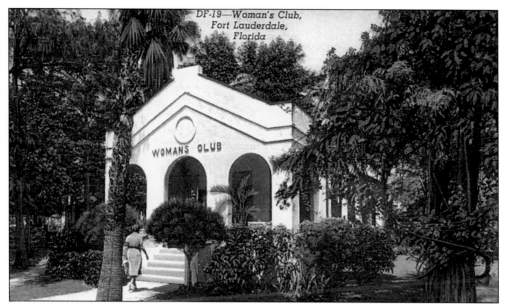

One of the city's oldest landmarks is the Fort Lauderdale Woman's Club, built for that organization in Stranahan Park, at the southeast corner of Broward Boulevard and Andrews Avenue, in 1917. The club once wielded substantial political clout and was the force behind many of the community's early civic improvements. Originally designed by famed architect August Geiger, the clubhouse was altered and enlarged in the 1940s. (P1961.)

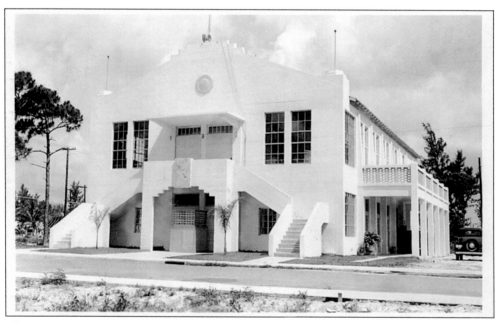

The William C. Morris post of the American Legion was Broward's first, founded in 1926 and named after a Fort Lauderdale soldier who died in action during World War I. Many prominent members of the community were members of the post, and in 1937, they built a permanent home at 605 Southeast First Street. The structure, designed in a blend of Mission and Art Deco styling peculiar to the 1930s, survived until the 1990s. (P1090.)

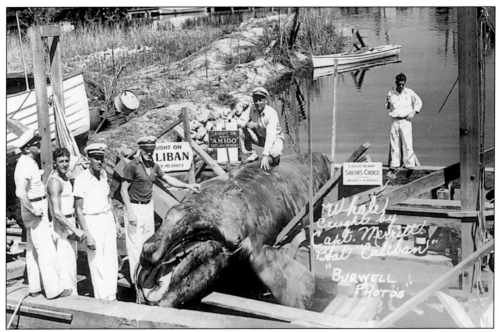

In the 1930s, game fishing had become a major tourist draw in the area, and anglers lacked the modern sensibilities regarding reeling in marine mammals. This postcard features a whale caught aboard the charter boat *Amigo* (the inscription at lower right is incorrect). The scene was shot at the docks on New River by Marine Ways, today the site of a marina west of the Andrews Avenue bridge on the south side of the river. (P1153.)

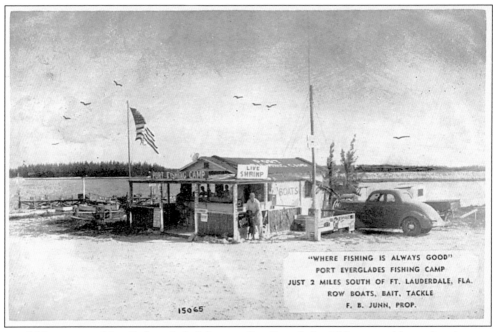

Local fisherman could easily launch their boats at Port Everglades. This postcard is an advertisement for a rustic looking fishing camp there, owned by F.B. Junn and dated 1938. (P1137.)

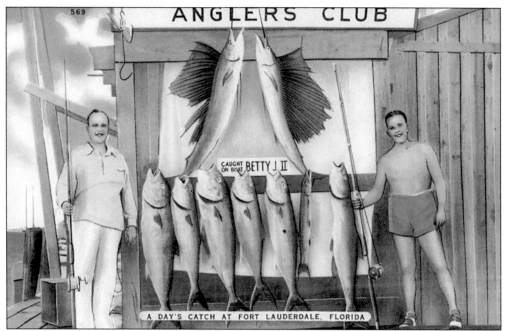

Tourists have long posed with their catch at Fort Lauderdale's docks. This rather comical and highly enhanced image features two visitors with their catch from the *Betty J II, c.* 1930s. (P2426.)

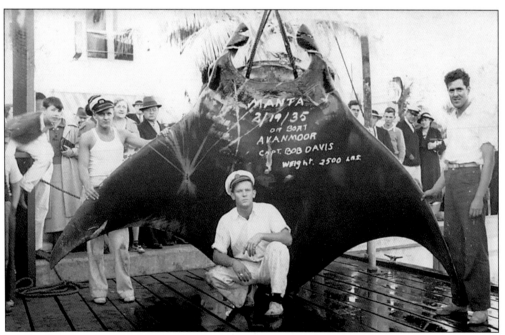

It is hard to imagine Fort Lauderdale's waters populated by beautiful creatures such as this large manta ray. Today's release policies cannot overcome the loss of natural habitat for such creatures, a product of increased human population and pollution of local waters and reefs. This 2,500-pound ray was caught aboard the *Avanmoor* on February 19, 1935. (P1152.)

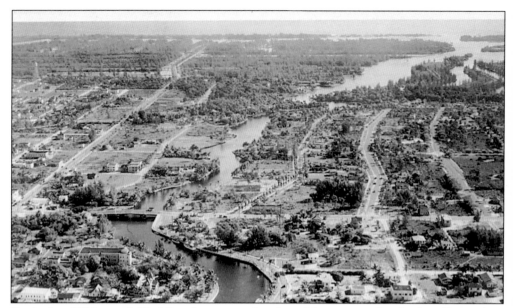

By the late 1930s, south Floridians began to enjoy financial recovery after the long Depression. But the ambitious "island" projects of the mid-1920s had essentially halted, and the isles of Las Olas (at far left) and the Rio Vista Isles (far right) can be seen undeveloped and covered with vegetation—not houses. The span over New River is the Federal Highway bridge, constructed in 1926, the predecessor to the Kinney Tunnel. (P297.)

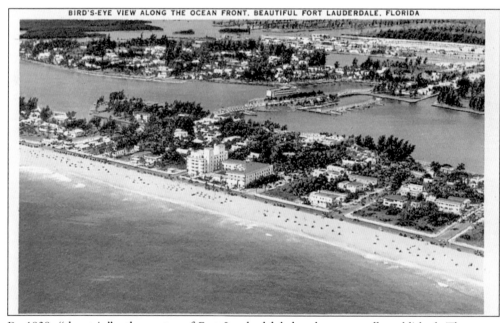

By 1939, "the strip"—the center of Fort Lauderdale's beach—was well established. The now-enlarged Lauderdale Beach Hotel stands at center. In the center background can be seen the "mole" in the Las Olas Causeway—an island between the fixed span bridge and swing bridge. Anchored there is the floating hotel Amphitrite, which was finally removed as a navigational hazard in 1942. (P2551.)

Four

1940s

It's been very nice weather—everything is terribly crowded. . . . Jane to Mrs. Brooks in Memphis, Tennessee, January 1944.

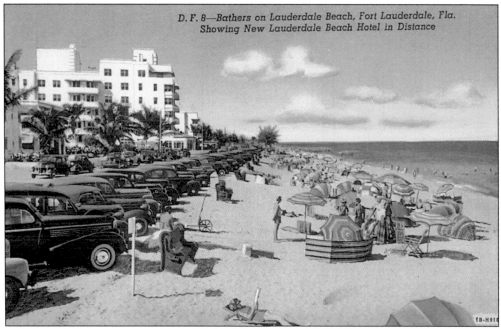

D. F. 8—*Bathers on Lauderdale Beach, Fort Lauderdale, Fla. Showing New Lauderdale Beach Hotel in Distance*

Even World War II did not halt tourism in Fort Lauderdale. Despite rationing, difficulty of travel, and the occupation by servicemen of several beach hotels, the city was full to bursting. Every available hostelry housed servicemen and their families. The winter season of 1945–1946 was the most prosperous the community had ever experienced—the start of a new "boom." This postcard features the beach looking north from Las Olas Boulevard in the early 1940s. (P1285.)

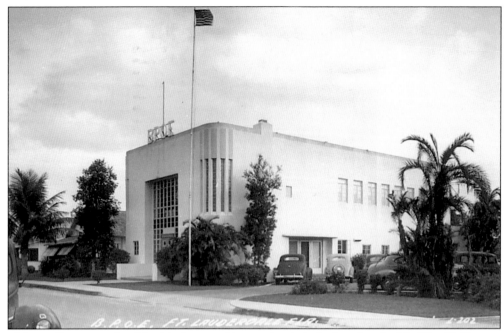

This excellent example of Art Moderne architectural style is the Fort Lauderdale Elks Clubhouse, built on Southeast Fourth Street (just north of New River) and just east of Third Avenue in 1940. In 1966, the popular club was extensively remodeled but remained the Elks' home until 1995. (P2414.)

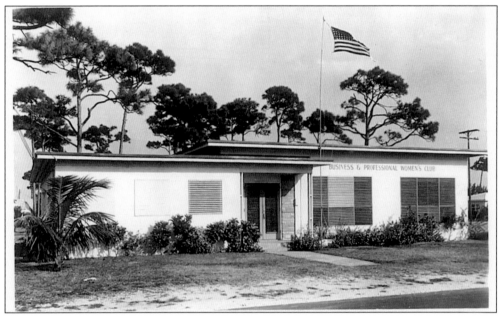

An active local organization since 1926, the Business and Professional Women's Club included many of the community's most influential women—"feminists" long before the word became popular. The members built this clubhouse in Poinciana Park on Southeast Fourth Avenue in 1940; it served as their home until 1972, when it was acquired by the city. (P1088.)

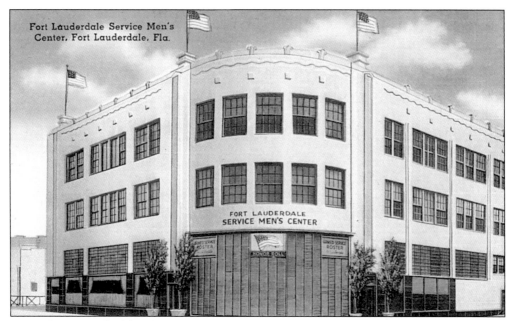

One of Fort Lauderdale's finest community efforts was the completion of the Service Men's Center, constructed in the shell of the old Pioneer Department Store on Las Olas at Southeast First Avenue. During the war it provided respite and entertainment for thousands of soldiers from throughout South Florida. (P2462.)

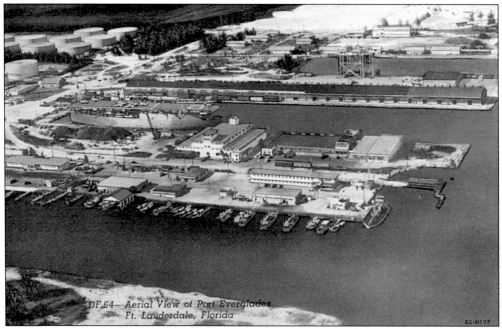

Port Everglades was one of the county's most strategic locations during the war. This aerial view shows an escort aircraft carrier with planes being offloaded, probably shortly after the end of the war, in 1945. Also visible are the wooden barracks and other structures built for the U.S. Navy Section Base located there in the war years—seen at the top right of the image. (P2416.)

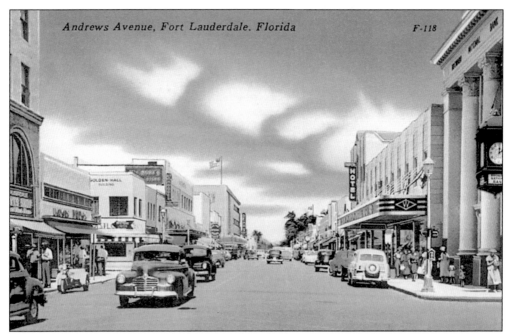

The postwar years brought a new era of development to Fort Lauderdale. One place this was most evident was in the growth of the downtown area. This scene features a 1940s view looking north on Andrews Avenue from Las Olas Boulevard. The structure with the flag at center is the new Burdine's Department Store, which opened in 1947. (P1476.)

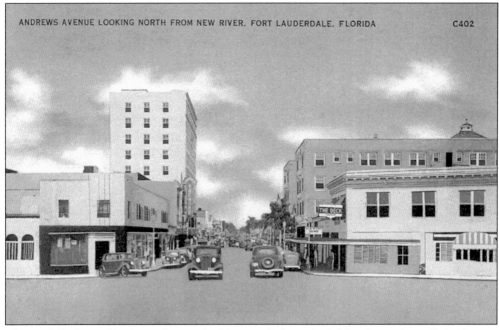

This *c.* 1940 view of Andrews Avenue looking north from the bridge shows the stylistic changes wrought by time. Many structures, like the building at the left corner, were updated with a popular façade of black tile and deco-like detailing. (P1746.)

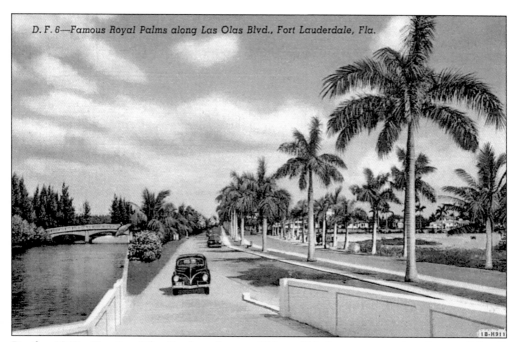

D. F. 6—Famous Royal Palms along Las Olas Blvd., Fort Lauderdale, Fla.

By the 1940s, East Las Olas Boulevard was still beautiful, but not so quiet. A new "island" development was completed in the late 1930s—the Stilwell Isles. Fine homes began to emerge on the finger islands south of Las Olas almost immediately. These postcard views show Las Olas looking east (above) and west (below) in the 1940s. (P1742 and P454.)

D. F. 3— New Homes on Las Olas Blvd., Fort Lauderdale, Fla.

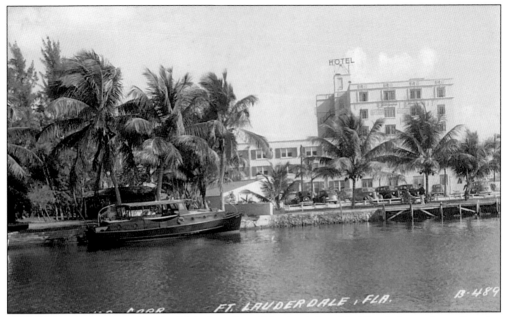

One of downtown Fort Lauderdale's "survivors" is the Riverside Hotel, located on East Las Olas just east of the tunnel. Originally designed by Francis Abreu and constructed in 1936, the structure was a departure from his popular Spanish-style works; it featured neo-classical details. In the 1940s it was known as the Champ Carr. Today the structure has been greatly enlarged, but the original core can still be seen from the street. (P2793.)

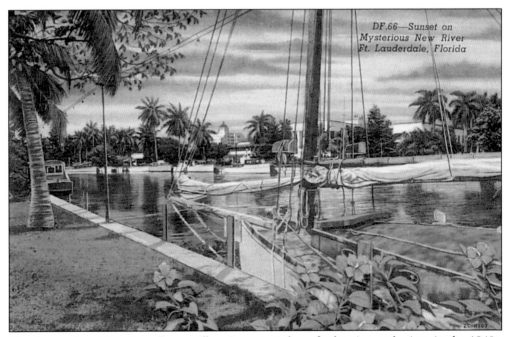

The "mysterious New River" was still an important draw for boating enthusiasts in the 1940s. This river scene features the seawalls along South New River Drive, c. 1940s. In the center ground can be seen the pointed tower of the Governor's Club Hotel. (P996.)

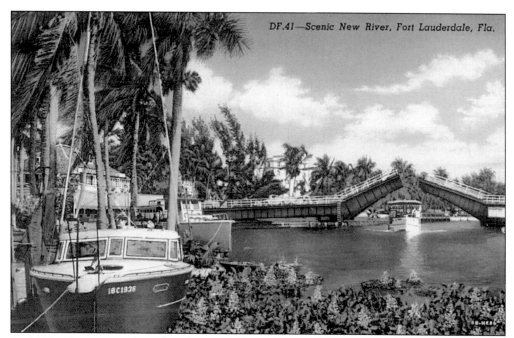

In 1939, pioneer Ivy Stranahan leased her beautiful riverfront home to the E.J Blackwells, who added on to the home and opened the Pioneer House restaurant. A popular and beloved destination for 40 years, the restaurant closed in 1979 but was restored and is today a house museum. These postcard views feature a look at Pioneer House in the early 1940s looking east, with the Federal Highway bridge at center (above), and west, in a view take from that same bridge (below). (P1003 and P1390.)

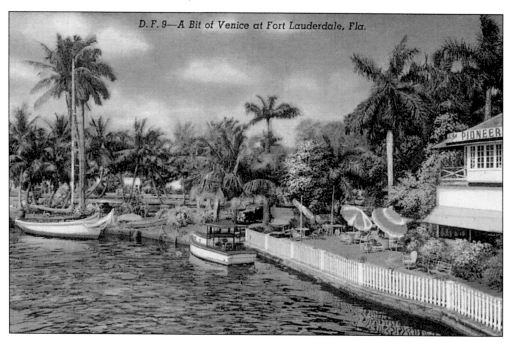

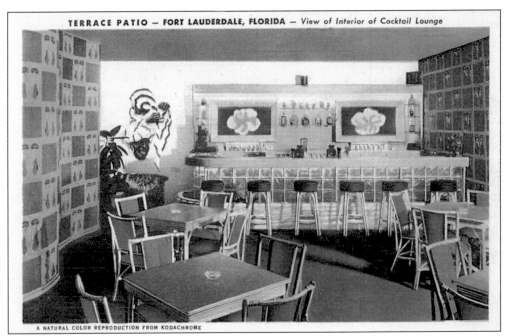

The latest in 1940s decorating is documented in this postcard view of the interior of the Terrace Patio lounge. The Patio was located at 2400 East Las Olas Boulevard and opened in 1942. (P2785.)

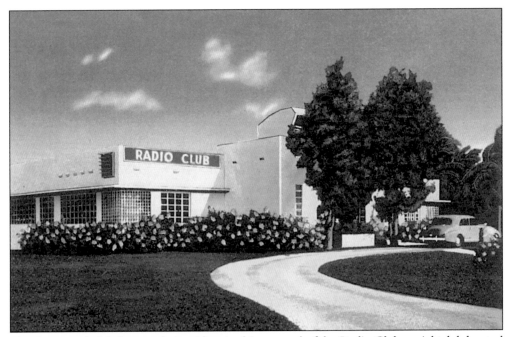

The then-trendy Moderne style is evident in this postcard of the Radio Club, a nightclub located at 2700 South Andrews Avenue. A popular and stylish spot, it was replaced by the Reef Club, constructed in the late 1950s. (P2780.)

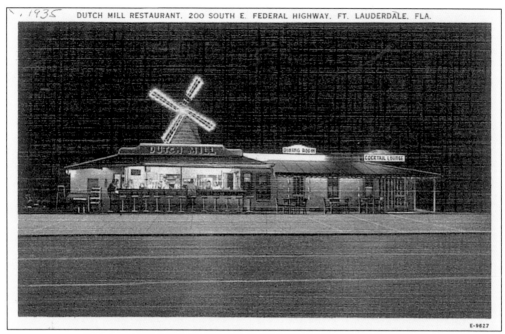

The Dutch Mill diner, which was open from 1940 until the late 1950s, was located at 200 South Federal Highway and had an irresistible appeal for children with its novelty design. This nighttime view gives it a rather more elegant appearance that it had by day. (Courtesy Broward County Historical Commission.)

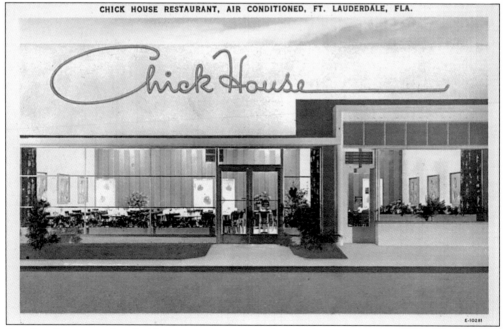

Another fine example of mid-century design was the Chick House, located at 1008–1012 East Las Olas Boulevard. The restaurant was in service from the early 1940s until the late 1950s. This postcard, dated 1948, touts one of its most important attractions: air conditioning. (P2266.)

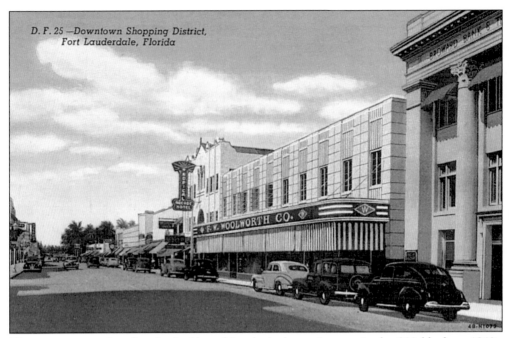

D. F. 25 —Downtown Shopping District,
Fort Lauderdale, Florida

These two postcards reflect both sides of South Andrews Avenue in the 200 block, *c.* 1940s. The picture above shows the east side of the street north of Las Olas; today this is the site of the Museum of Art. The buildings in the view below, on the west side of the street, are mostly intact today. (P2713 and P1967.)

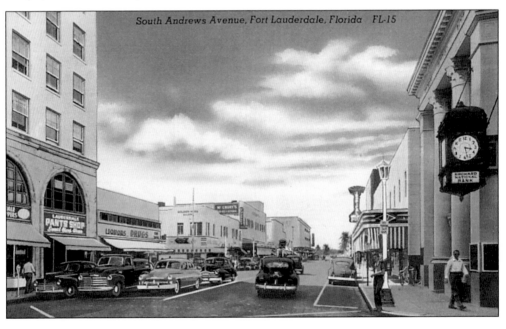

South Andrews Avenue, Fort Lauderdale, Florida FL-15

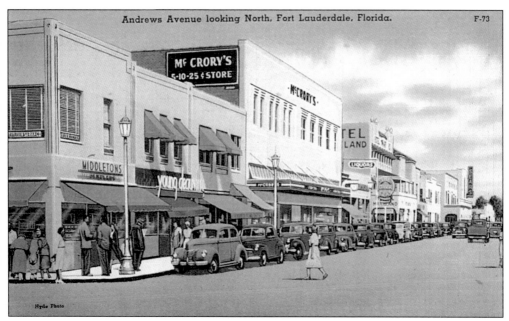

Two more postcard views of South Andrews Avenue in the 1940s reveal the west side of the street but from two perspectives. Above is the view looking north from the intersection of Las Olas—many of these structures are still standing, including the McCrory's building. Below is the view looking south from just south of the intersection of Second Street (the Maryland has since been demolished). (P1966 and P1168, Gene Hyde Collection.)

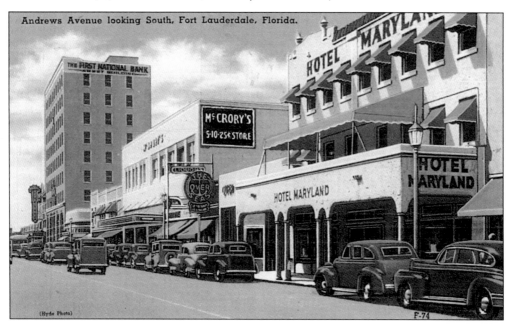

Andrews Avenue looking South, Fort Lauderdale, Florida.

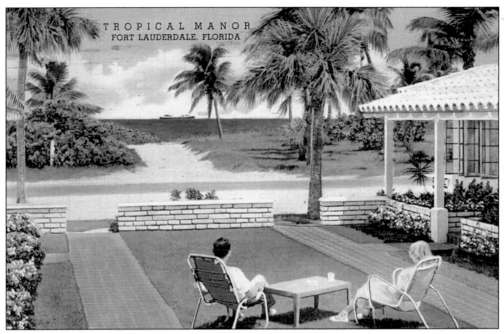

The Tropical Manor apartments, built in the late 1940s, stood at 2101 North Ocean Boulevard at a time when Fort Lauderdale's "north beach" area was still under development and an ocean view was not so hard to come by. The note on the card relates, "This place has everything you would want." (P2398.)

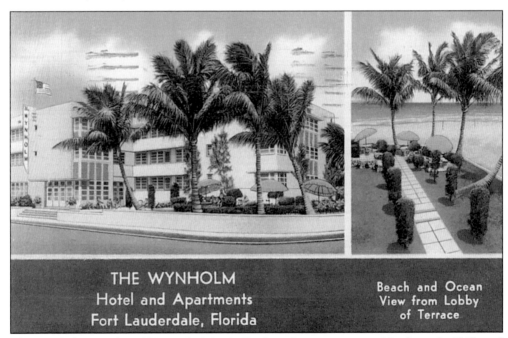

The Wynholm Hotel, at 321 North Atlantic Boulevard, was constructed in the early 1940s and reflects the Art Moderne and International styles of architecture. In 1944, hotel guest Jane Perry reflected on war time conditions here: "Everything is terribly crowded." (P2399.)

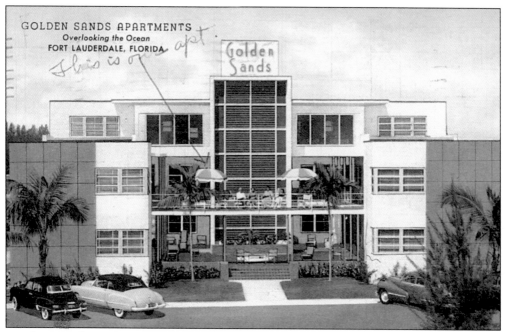

Newly opened in 1949, the Golden Sands Apartments was one of the earliest apartment houses in the newest part of the beach opened up for development, Birch Estates. The advertisement claimed it was "overlooking the ocean," but the postcard's author revealed "it is really a block away from the ocean." The Sands reflects the trendy architectural style of the time now dubbed "Mid-Century Modern" and still stands at 519 North Birch Road. (P2393.)

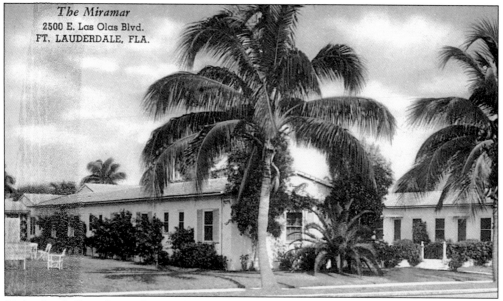

It's hard to believe that such a modest hotel once graced the lot at 2500 East Las Olas Boulevard. The Miramar, "a delightfully different hotel," was a "mom and pop" establishment built in the early 1940s at the north end of Riviera Isles. It was replaced in the late 1960s by the large Marine Towers condominium complex. (P1671.)

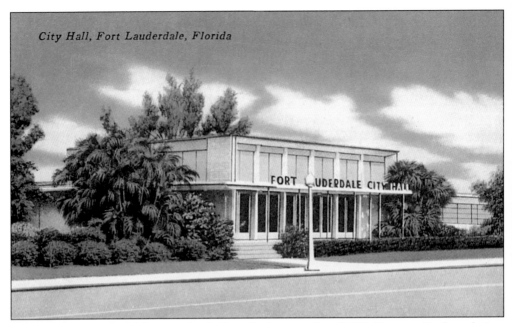

City Hall, Fort Lauderdale, Florida

In 1948, Fort Lauderdale's new city hall, a classic example of Mid-Century Modern design, opened on North Andrews Avenue. In those days, the building housed the central fire station and police headquarters as well as other city offices. The rapidly growing city government quickly outgrew the facility and supplemented office space with "annexes." In 1969, the current city hall was opened almost across the street, leaving old city hall to serve as annex space. (P2520.)

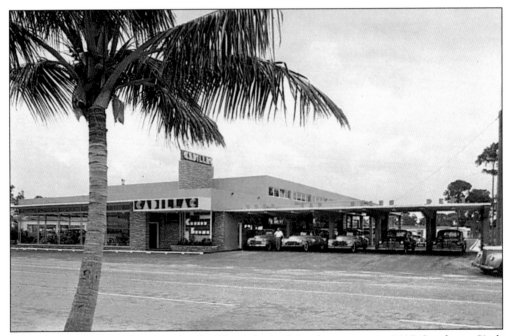

In the late 1940s, Connor Brown Cadillac relocated its showroom to 1415 Southeast Sixth Avenue—the up and coming South Federal Highway corridor on the way to the airport. An example of mid-century commercial design, it featured swank Deco-like signage. (P2253.)

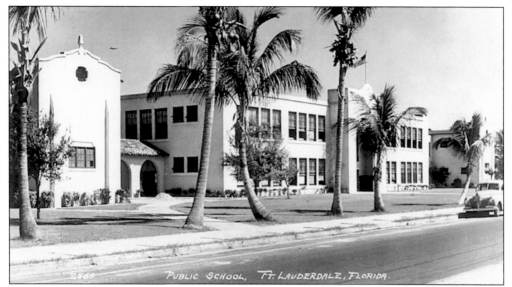

One of Fort Lauderdale's most beloved institutions is Fort Lauderdale High School, home of the "Flying Ls," shown in its heyday in the 1940s. Built in 1915 as Central School, all ages, from kindergarten through 12th grade, were accommodated on campus. In 1962, Fort Lauderdale High moved to its current home on Northeast Fourth Avenue, and the beautiful old Mediterranean-style buildings were demolished in the 1970s. (P2782.)

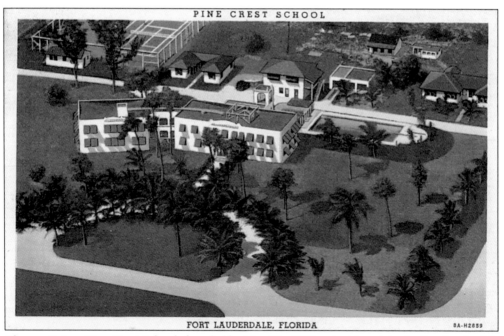

The prestigious Pine Crest School, founded by Mae MacMillan, had its origins in Fort Lauderdale in 1934 on South Andrews. By the 1940s, Pine Crest, now with boarding facilities, had relocated to the former Memorial Hospital site at 1515 East Broward Boulevard, as shown in this postcard. The building was demolished in 1965, after Pine Crest relocated to its current campus on Northeast Sixty-second Street. (P2509.)

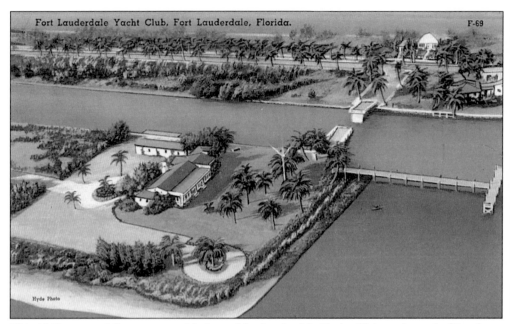

This 1940s postcard features an aerial view of the Lauderdale Yacht Club, at the end of Southeast Twelfth Street. The club has long been the scene of parties, gatherings, and regattas and continues today as one of the favorite haunts of the city's social elite. (P2706, Gene Hyde Collection.)

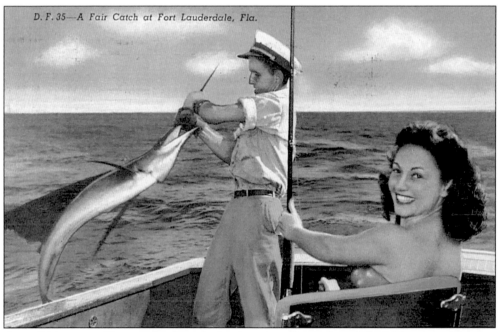

Game fishing was still a popular draw for locals and tourists in the 1940s. This postcard features this note to Nelly from Hulda and Otto: "We sure having a nice time resting and this is the fish Hulda got this morning. Ha Ha!" (P1463.)

In 1934, the city permitted the construction of a private yacht harbor along the "mole" in the center of the Las Olas Causeway. These two views show the Lauderdale Beach Yacht Harbor in the 1940s. The wooden docks shared the small island with the Amphitrite floating hotel—both were considered eyesores by many. The docks were removed by the 1950s, and the island itself was removed for the construction of the new Las Olas Causeway in the mid-1950s. (P2244 and P60.)

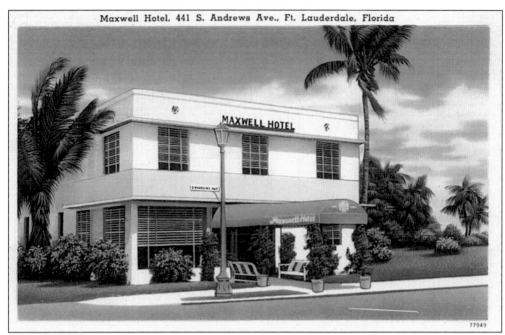

Maxwell Hotel, 441 S. Andrews Ave., Ft. Lauderdale, Florida

The modest Maxwell Hotel, another example of the local Moderne style, was built in 1940 at 441 South Andrews Avenue, near the courthouse and just south of the commercial district. Through the years it has served as apartments and eateries, and although somewhat dilapidated, it still stands—looking much like this postcard view. (P2779.)

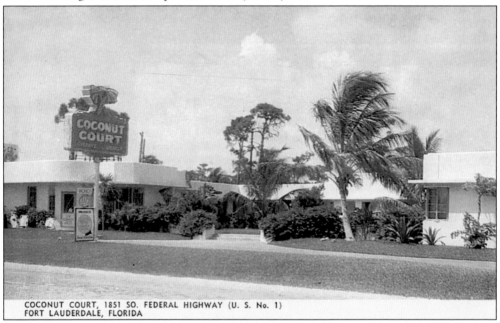

COCONUT COURT, 1851 SO. FEDERAL HIGHWAY (U. S. No. 1) FORT LAUDERDALE, FLORIDA

Architect Theodore Meyer designed the Moderne-style Coconut Court Motel, which opened in 1946 on South Federal Highway. It offered "modern hotel rooms all with private tile baths" and "cross ventilation" (translation: no air conditioning). Today, the modest establishment still stands as the Relax Inn at 1851 South Federal Highway. (P2340.)

The beautiful Mediterranean-style Tropical Arcade opened in 1926 on South Andrews Avenue, shortly before the September hurricane. It was home to many commercial establishments and the Tropical Hotel, located on the upper floors, serving business travelers. These 1940s postcards reveal a rare look at both exterior and interior of the arcade. The exterior shows the unfortunate results of "modernization," the addition of black tile façade on the lower floor, quite popular in the later 1930s and 1940s. The Arcade was another victim of downtown redevelopment in the 1970s, and today the Museum of Art stands on this site. (P2794 and P396.)

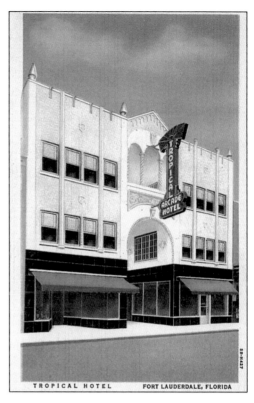

TROPICAL HOTEL FORT LAUDERDALE, FLORIDA

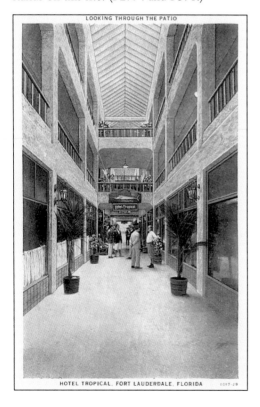

LOOKING THROUGH THE PATIO

HOTEL TROPICAL, FORT LAUDERDALE, FLORIDA

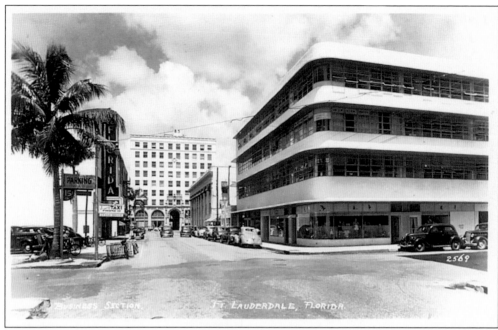

These two postcards feature East Las Olas Boulevard before it was rerouted to accommodate the enlarged approach of the current Andrews Avenue bridge. The view above shows the busy adjunct to the city's main business corridor (Andrews), looking west towards the Sweet Building. The handsome International-style building at right is the Blount Building, located at the corner of Southeast First Avenue. It opened in 1940 and was home to many physicians and other offices. The view below features the same block looking east, taken from the vantage offered atop the Sweet Building. Except for the latter, none of these structures survive today. (P2783 and P2784.)

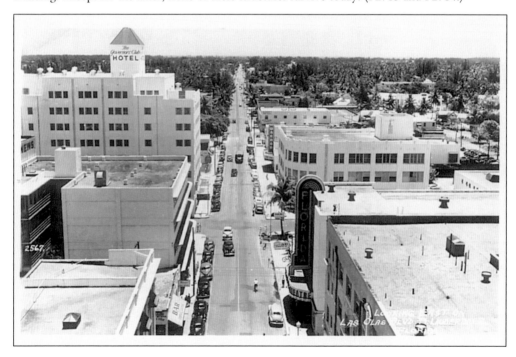

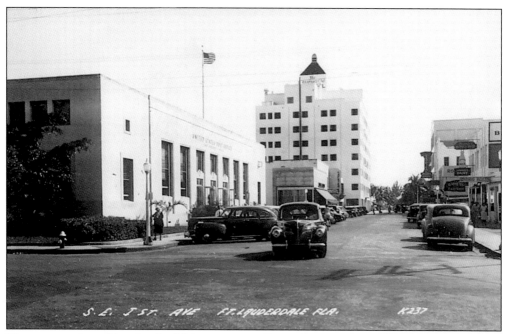

The construction of Fort Lauderdale's main post office in the 1930s helped extend the downtown business district to Southeast First Avenue, shown here looking south from Second Street. In the background is the rear of the Governor's Club Hotel. Today this street is the site of the city's parking garage. (P2710.)

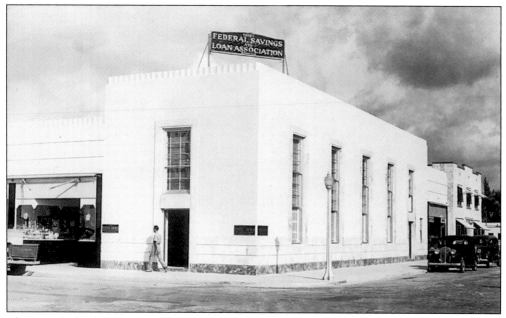

The First Federal Savings and Loans opened their Art Deco–influenced office at the corner of Southeast First Avenue and Second Street, across from the post office, in 1939. It remained at the site until a new branch was built in 1947. (P136.)

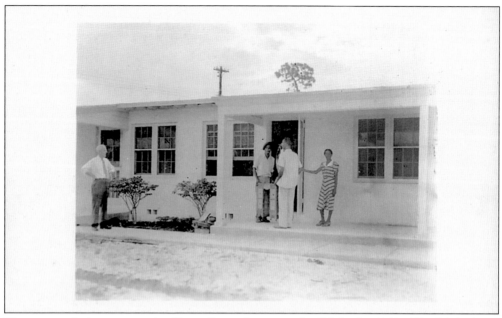

These unusual photo postcards offer a glimpse into everyday life in the 1940s. The Dixie Court Housing complex was created with the assistance of federal funds for African-American citizens in Fort Lauderdale and opened in 1940. The scene above captures the first "moving day," with the housing authority officials on hand to document the occasion. The image below shows a family at the complex surveying the damage after two back-to-back hurricanes resulted in terrific flooding throughout South Florida in 1947. Today Dixie Court still stands, not a derelict project but still maintained by the City of Fort Lauderdale, between Northwest Ninth and Eleventh Avenues, and Northwest Second and Fourth Streets. (P290 and P291.)

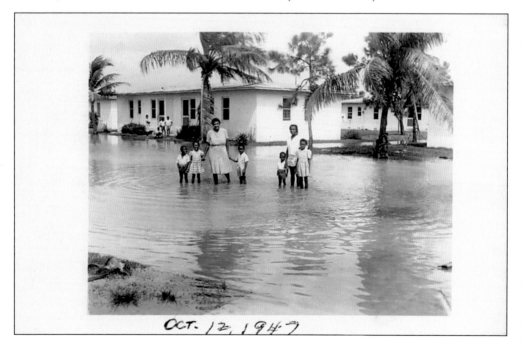

OCT. 12, 1947

Five

1950s

They call it cold here—but we snowbirds love it. . . . M to Mrs. Thompson in Worcester, Massachusetts, February, 1951.

In the 1950s, Fort Lauderdale's star attraction was the glamorous new marine and resort complex Bahia Mar, built on the site of former U.S. Coast Guard property at the south end of Fort Lauderdale's beach. Bahia Mar continues to draw international boating enthusiasts to the "Venice of America." (P1798.)

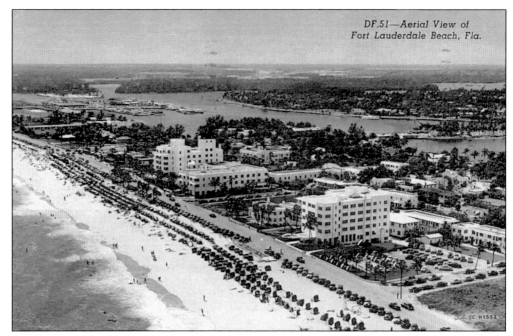

The 1940s-era hotels dominate the center of this aerial view of the beach looking south *c.* 1950. The new Bahia Mar Yachting Center can be seen at the upper left. The message reads, "You both should come down here. It's better than a doctor's medicine." (P1526.)

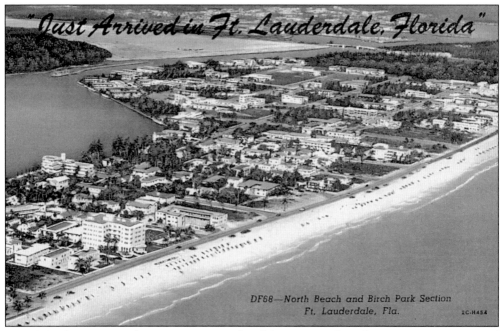

By 1950, the new Birch Estates area south of Sunrise Boulevard was experiencing rapid development shown in this view looking north and west. The cleared land at upper left is the soon to be Sunrise Shopping Center—now the Galleria Mall. (P1299.)

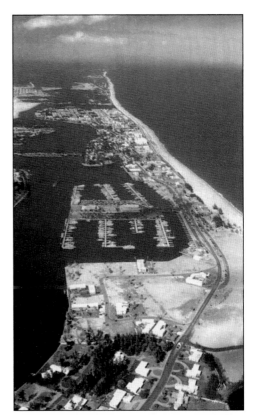

In the early 1950s, the area south of Bahia Mar became open for development, as revealed in the aerial view shown at right, looking north. In 1956 developer George Gill acquired the triangular piece of land at lower right for his spectacular modern beach hotel, the Yankee Clipper, shown below. The Clipper was the first in a wave of glamorous new hotels built along the beach. (P303 and P414.)

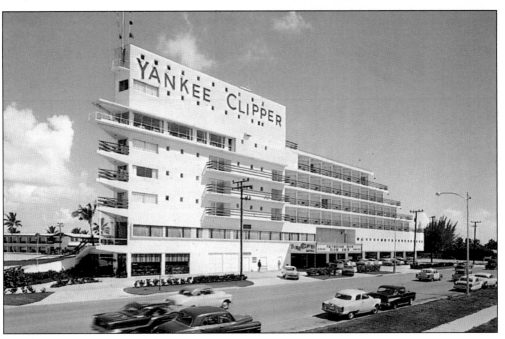

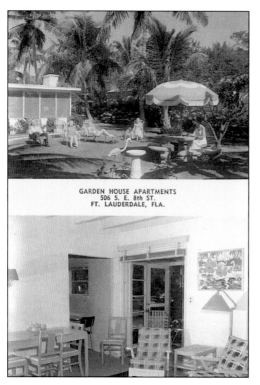

GARDEN HOUSE APARTMENTS
506 S. E. 8th ST.
FT. LAUDERDALE, FLA.

Modest apartment houses and motels proliferated in the postwar years in Fort Lauderdale in an attempt to meet the incredible influx of new residents and tourists. The Garden House Apartments at 506 Southeast Eighth Street, just west of Federal Highway, offered "screened porches and efficiency apartments." It also offered classic mid-century interior decorating, Florida style. (P2315.)

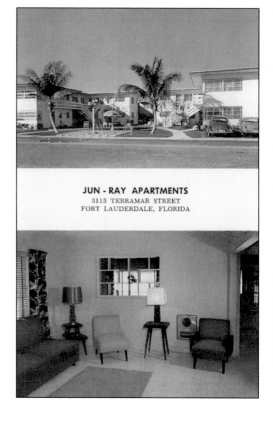

JUN - RAY APARTMENTS
3115 TERRAMAR STREET
FORT LAUDERDALE, FLORIDA

The Tarrymore Apartments, briefly known as the Jun-Ray Apartments, were built in the early 1950s at 3115 Terramar in the new Birch Estates section. The "new modern rooms" were equipped with "circulating electric heat"—a built-in heater can be seen in the bottom view of the interior. The Tarrymore still stands, little changed from earlier days. (P1678.)

Another classic Mid-Century Modern building, the Lauderdale Terrace apartments, operated on the beach at 3000 Castillo in the 1950s. Amongst the amenities offered were shuffleboard courts and a sundeck, visible at upper left. (P2322.)

The Las Olas Inn, one of Fort Lauderdale's oldest "motels," was a former lodge that gave Fort Lauderdale's grandest boulevard its name. By the 1950s, it was no longer an isolated getaway, but an aging set of structures on arguably the most prime real estate in town, at the south corner of Las Olas and Atlantic Boulevard (A1A); it was demolished in 1954. (P419.)

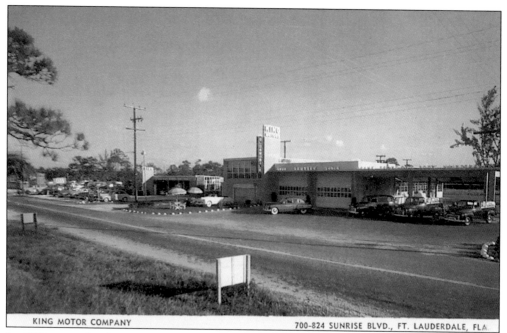

KING MOTOR COMPANY | 700-824 SUNRISE BLVD., FT. LAUDERDALE, FLA

In 1950, new developments emerged to the north of Fort Lauderdale's core, and Northeast Tenth Street gained prominence as an important east-west artery. In 1950 it was renamed Sunrise Boulevard. The King Motor Company moved its operations to "Sunrise" in the later 1940s—this view is in the early 1950s. Note the narrow road that was Sunrise just east of Federal Highway at the time. (P2261.)

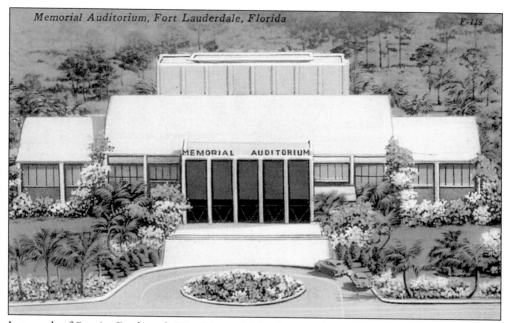

Just south of Sunrise Boulevard, War Memorial Auditorium had its opening in Holiday Park in 1950. Built with private and city funds as a memorial to all veterans, it has served as a venue for wrestling matches, graduations, and operas for over half a century. (P2772.)

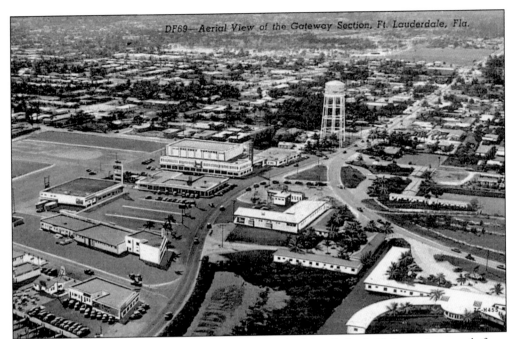

In 1950, the Gateway Shopping Center was opened where Federal Highway jogs north from Sunrise Boulevard. It was built on the site of the Clyde Beatty's Jungle Zoo—closed when nearby residents complained about noisy lions. The Gateway was considered "too far north of town," by some, to be successful. They were wrong. The Gateway in fact, is little changed today. Above, an aerial view looks west towards downtown, and below is a closeup of the parking lot, now reconfigured, and the west side shops. (P1362 and P2771.)

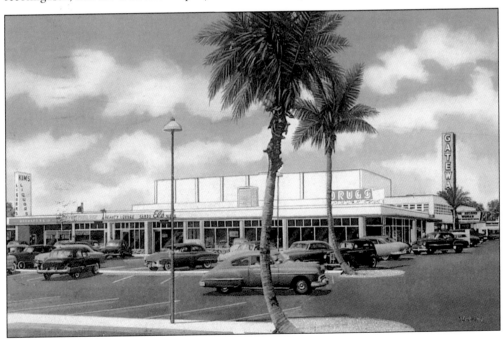

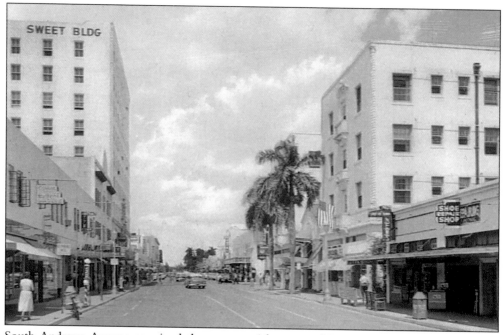

South Andrews Avenue remained the commercial center of Fort Lauderdale until the 1960s, before suburban shopping centers lured anchor stores away from downtown. This scene shows the familiar view looking north from the Andrews Avenue bridge, *c.* 1950s. (P1475.)

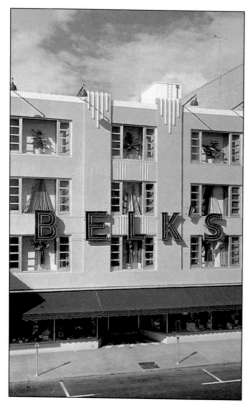

The Belk-Lindsey department store with its Art Deco detailing opened at 101 South Andrews Avenue in the early 1950s. It advertised itself as "Fort Lauderdale's complete new department store," and featured a "top floor bargain basement." By 1962, Belk's moved to a Pompano location. (P2256.)

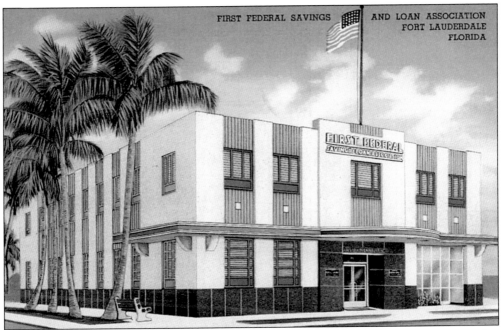

In the 1950s, First Federal Savings and Loan occupied this stylish building at 301 East Las Olas Boulevard. By 1953, the institution had grown enough to warrant a substantial addition—and another and another. The building has grown a number of floors and has been substantially remodeled but still survives at the northeast corner of Southeast Third Avenue and Las Olas. (P2269.)

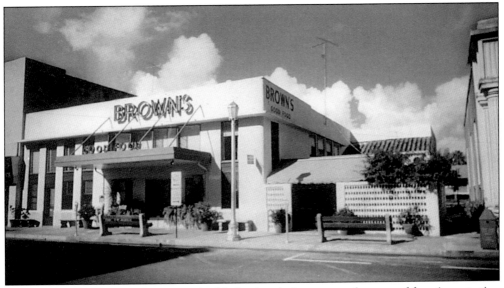

Brown's Good Food was a Fort Lauderdale landmark that operated at several locations starting in 1926. A "pot roast table" hosted local doctors, lawyers, and businessmen who wielded great influence in the community. All candidates for political office were sure to make a stop by Brown's. In the 1950s Logan Brown operated his restaurant at 229 Southwest First (Brickell) Avenue, where Las Olas Riverfront is today. (P91.)

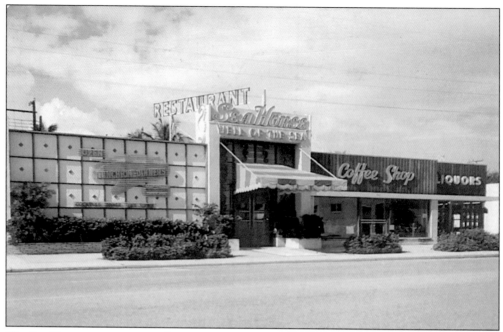

The Sea Horse was a very popular eatery at 904 East Las Olas Boulevard in the 1950s, 1960s, and 1970s. This postcard view, dated 1955, reveals the building's mid-century styling. Several popular restaurants have made their homes at this location in ensuing years. (P2254.)

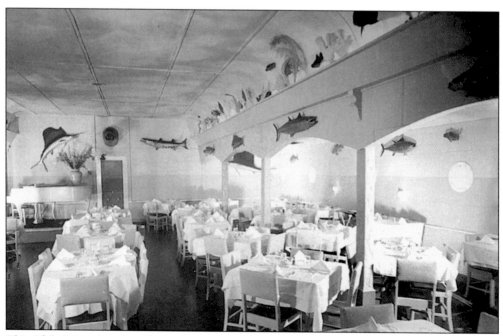

This "fishy" interior shot shows the Beachcomber Restaurant, located at 2915 East Las Olas Boulevard in the 1950s. The restaurant operated at this address from 1946 until 1954. (P2249.)

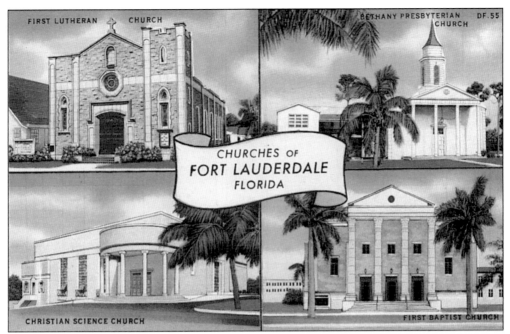

Fort Lauderdale boasted a number of beautiful churches in the 1950s. The church at upper left originally served as Saint Anthony's Catholic Church and was located on Las Olas Boulevard. In the late 1940s it was disassembled, moved, and reassembled at a new location on Northeast Fourth Avenue. There it was reestablished as the First Lutheran Church and opened for services in late 1949. (P1455.)

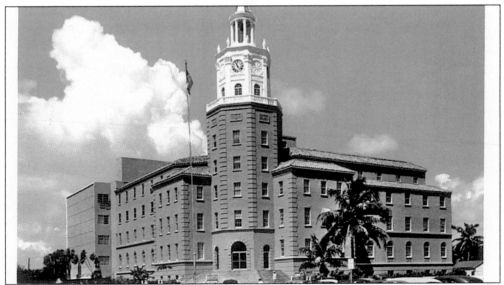

By the 1950s, a series of additions had begun on Broward County's handsome 1928 courthouse on Southeast Sixth Street and Third Avenue, south of New River. By 1963, only a close look at the plans could locate the old courthouse under the new shell. Referring to the then-outdated postcard shown here, County Commissioner Frank Adler quipped, "Maybe the Historical Society is printing them. . . . They might be valuable some day." (P314.)

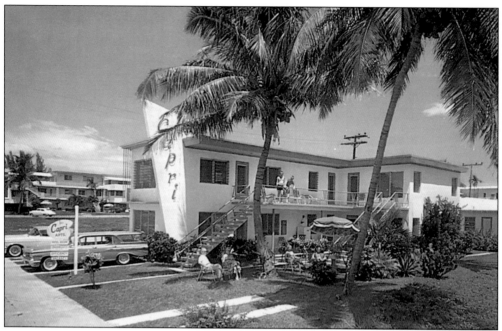

The Capri Apartments, typical of the beach area dwellings springing up in the 1950s, opened at 420 North Birch Road in the late 1950s. Although hemmed in by other structures and stripped of its swingy name, the building still stands. (P2203, Gene Hyde Collection.)

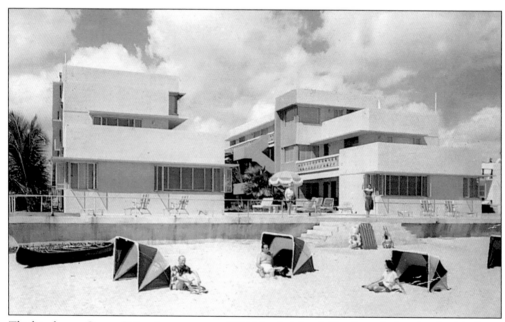

The handsome Ocean Drive Apartments at 1924 North Atlantic Boulevard, showing Art Moderne and International-style influences, opened in the late 1950s on the "north beach." Historically, most beach residences were not literally on the beach—a road separated the two—but the new buildings north of Birch State Park afforded the opportunity for true beachfront living. (P389, Gene Hyde Collection.)

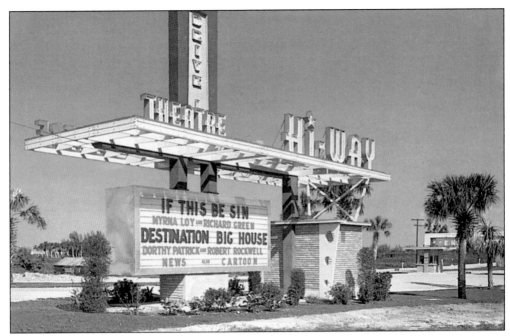

The 1950s were the classic era of the "drive-in" theater. Locals battled mosquitoes and stifling humidity to view the big screen at the Hi-Way, which opened on South Federal Highway, south of the airport, in 1954. The films weren't exactly first run—the two on the marquee were made in 1950. The Hi-Way gave way to the by-way and was demolished in 1982. (P2266A.)

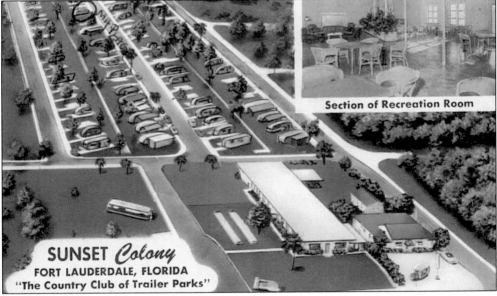

Since the 1920s, many Floridians have called a "mobile home" home. One of Fort Lauderdale's larger trailer parks was the Sunset Colony, which opened in 1954 on Broward Boulevard, just west of today's I-95. The aging facility has lost many tenants but still survives. In 1958 resident Mr. H. wrote to his friend Gladys of Battle Creek, "First to let you know I am not married. We have about 35 widows in our park—but none looking for an 80-year-old 'Daddy.' " (P2775.)

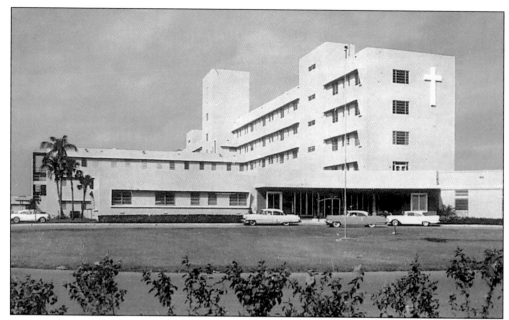

In the 1950s, the medical community raised $1.25 million dollars to build a new private hospital to meet the needs of a rapidly growing area. Holy Cross opened its doors in late 1955 on North Federal Highway, just south of Commercial Boulevard. It was surrounded by fields and close to the infamous "Porky's" bar, just to the south. Today it has grown tremendously in size and spawned another commercial district near the northern city limits. (P1468.)

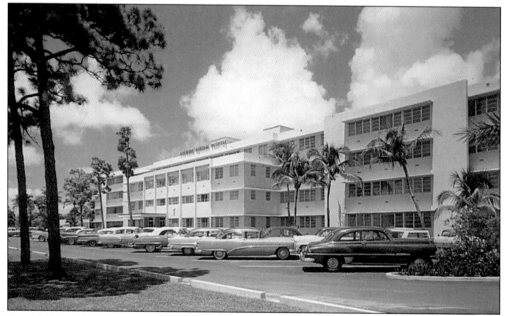

Founded in 1939, Fort Lauderdale's oldest hospital is Broward General, located on South Andrews Avenue just north of Seventeenth Street. The construction of Holy Cross helped encourage an expansion of its outdated facilities and increase its emergency services in the mid-1950s. (P322.)

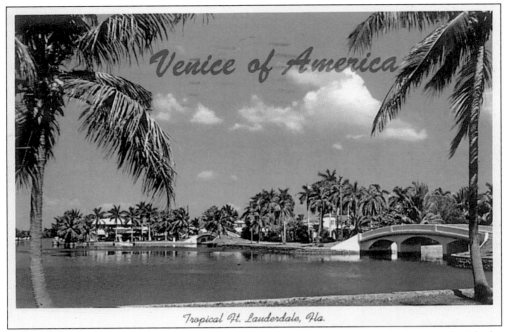

The author of this postcard wrote in 1959, "Henry's sister was very much impressed with the beautiful homes on the canals." This view shows the "hump backed bridges," of fond memory, in the Seven Isles neighborhood. (P2774.)

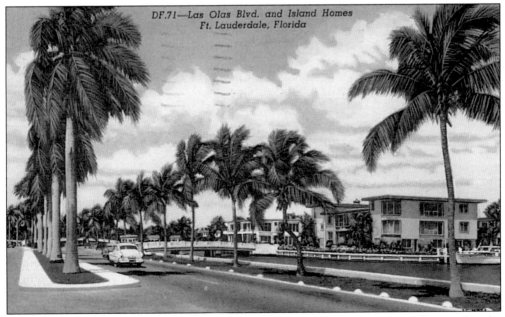

By the 1950s, development had resumed in the islands north of Las Olas, originally started in the boom of the 1920s. This view of Las Olas documents the stylish Mid-Century Modern apartment houses built on Isle of Venice—still in place and still stylish, c. 1955. (P1739.)

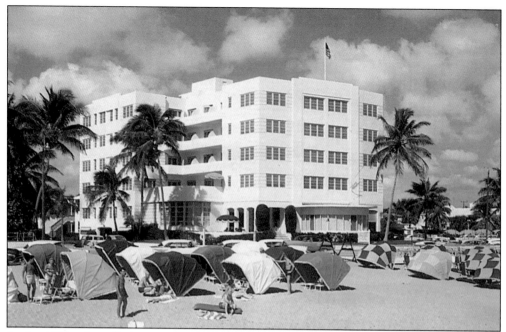

In the 1950s, the still glamorous Trade Winds (above) and Lauderdale Beach (below) hotels, located centrally on Fort Lauderdale's "strip," were popular with area tourists. During the war years, both served as radar training schools, and access to the hotels and the beachfront near them was restricted. (P2778 and P2773.)

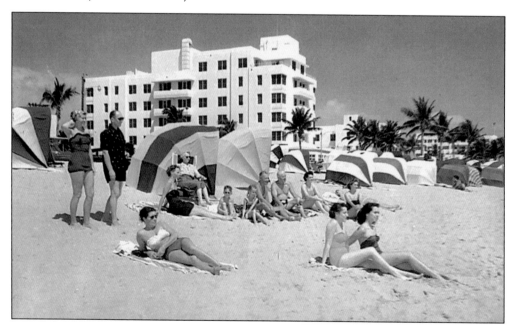

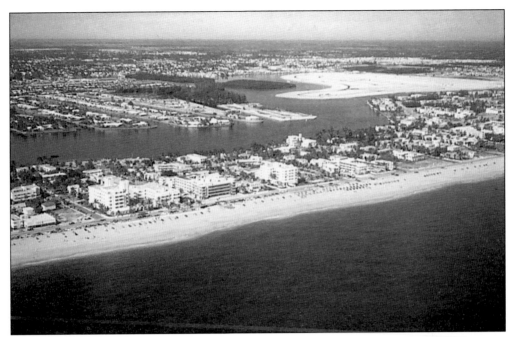

These two aerial views reveal Fort Lauderdale's beach in the 1950s, looking north. Above, the more distant view shows the Sunrise Intracoastal neighborhood—as a sandy white patch—about to be developed in the mid-1950s. Below, the close up view reveals the beachfront little changed, but Sunrise Intracoastal is already substantially developed by the end of the decade. (P2770 and P1289.)

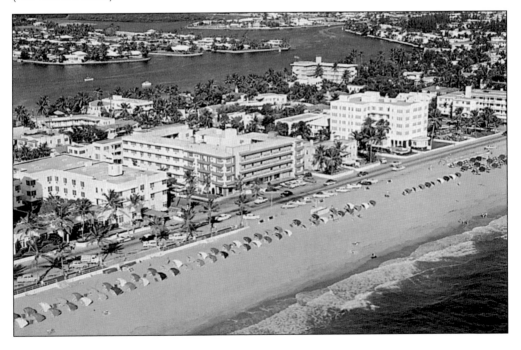

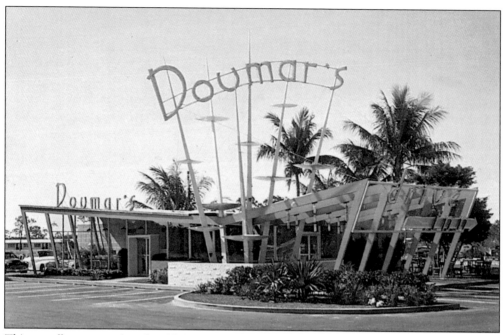

This excellent example of Mid-Century Modern architecture—with a sense of humor—is Doumar's Drive-In, which survived from 1954 until the 1960s at 3001 North Federal Highway. (P2777.)

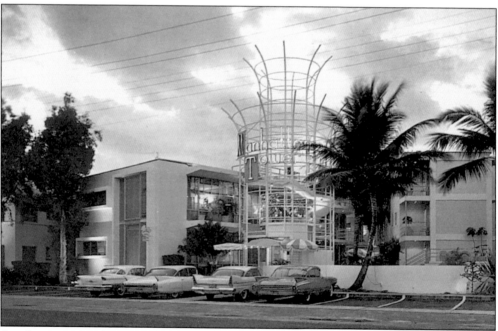

Another example of Mid-Century design is the Manhattan Tower apartments on the beach, built in 1954 in the Birch Estates. It advertised the newest in luxuries—"central air conditioning." Today the Manhattan Towers survives in its original glory at 701 Bayshore Drive. (P2360.)

Six

1960S

The beach at Fort Lauderdale, Florida, during Easter vacation is a must for College Students from all over the country. —Caption from Fort Lauderdale postcard, *c.* 1967.

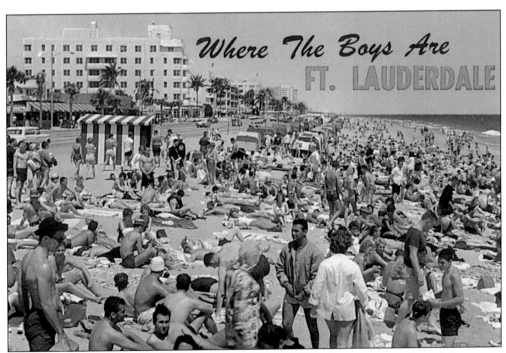

The modest-budget film *Where the Boys Are*, documenting the spring vacation phenomenon in Fort Lauderdale, premiered at the Gateway Theatre in December of 1960. The next spring, 50,000 students invaded the beach, overwhelming the community. Spring Break dominated Fort Lauderdale's image for the next 20 years, when city fathers actively encouraged a move to a new venue (Daytona). (P1286.)

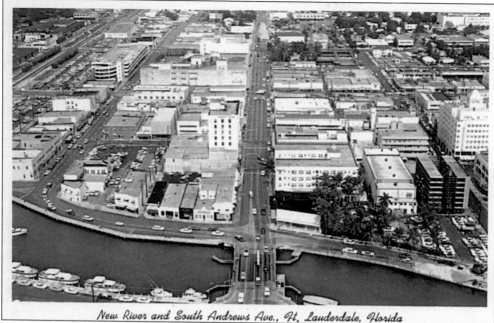

New River and South Andrews Ave., Ft. Lauderdale, Florida

Vast redevelopment projects, begun in the 1970s, drastically changed the face of the city's core—shown in these two aerial views from the 1960s. Above, the view looking north on Andrews Avenue reveals that southbound traffic was routed to Southwest First Avenue, to the left, due to downtown congestion. Below, the view looking northwest along New River reveals the new Southeast Third Avenue bridge, which opened in 1960. (P2037 and P1165.)

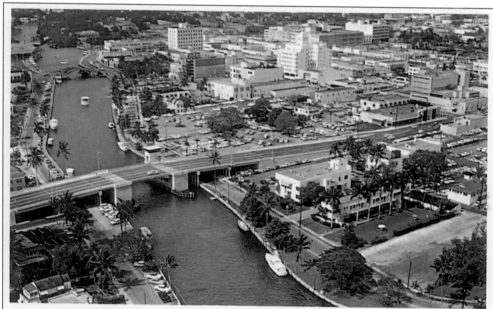

Bridge over New River and 3rd Ave., Ft. Lauderdale, Florida

114

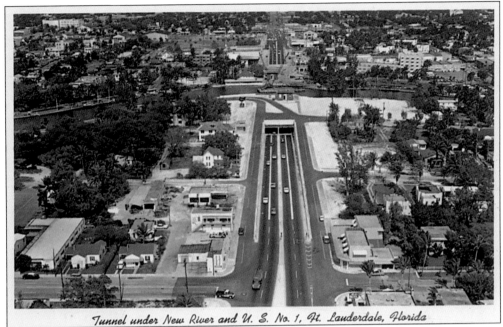

Tunnel under New River and U. S. No. 1, Ft. Lauderdale, Florida

By the 1940s, the Federal Highway bridge over New River was deemed to be the "worst bottleneck on U.S. One from Maine to Florida." A solution was found in the completion of Florida's only vehicular tunnel, in 1960. This view shows the new tunnel looking north; construction is still visible on the river. (P1161.)

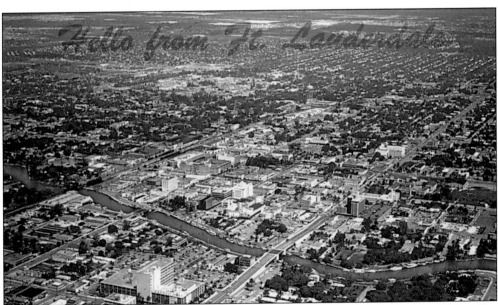

Fort Lauderdale's growth continued at a phenomenal rate in the 1960s, as documented in this aerial view looking north and west sometime after 1963. At the bottom center is the extensively remodeled Broward County Courthouse. By the 1970s, growth of the city had slowed, as it began to face increasing competition for new residents from neighboring municipalities, particularly to the west, emerging throughout Broward County. (P1365.)

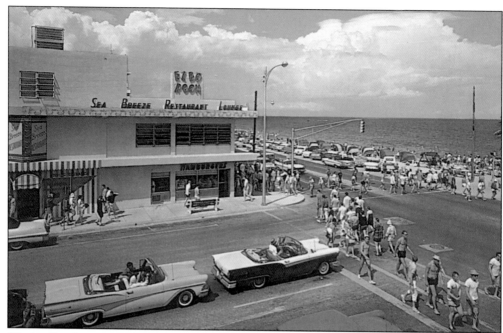

"Spring Break central" was and is the famous Elbo Room, located at the north corner of Las Olas and A1A, shown in this classic 1960s shot. Featured in the film *Where the Boys Are*, the Elbo Room and Seabreeze Restaurant replaced an earlier structure on the same site in 1956. (P2768.)

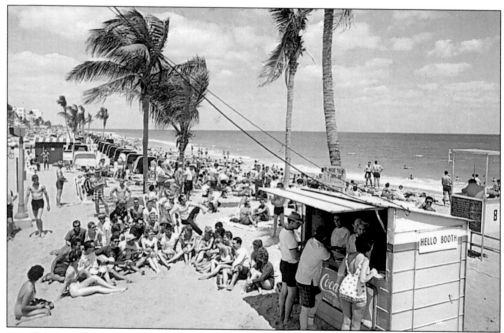

City fathers attempted to accommodate the college crowd with organized activities and orientation booths shown in this view of the beach looking north from Las Olas. The innocent high jinx of the 1960s reported in the local papers seem tame by comparison with the dangerous behavior observed in the overcrowded 1980s. (P1298.)

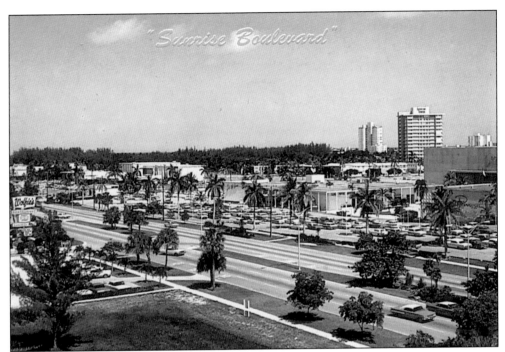

In the 1960s, the convenience of suburban shopping centers began to draw retail businesses away from downtowns throughout urban America. The view above (looking south) reveals the great improvements lavished on the former Tenth Street Causeway—Sunrise Boulevard—now giving Las Olas Boulevard serious competition. Below, the view looking west from the Intracoastal documents the growing Sunrise Shopping Center after 1961, when the exclusive Jordan Marsh department store moved to the center. Today this is the Galleria Mall. (P1477 and P1606.)

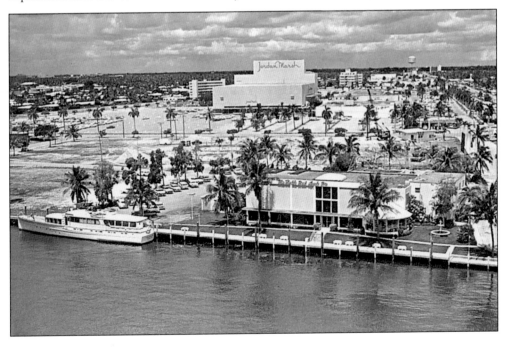

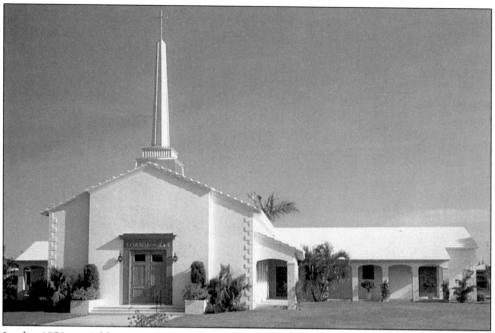

In the 1950s, neighbors in and around the Harbor Beach neighborhood of Fort Lauderdale needed a church. Together they built the non-denominational Church by the Sea at 2700 Mayan Drive. This image features the beautiful little church in the 1960s. (P2769.)

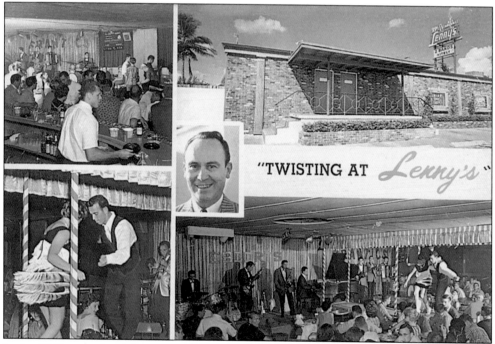

In the 1960s, popular night spots such as Lenny's, located on South Federal Highway just north of the airport at Southeast Twenty-eighth Street, featured live music and the latest in dance crazes—the Twist. (P1602.)

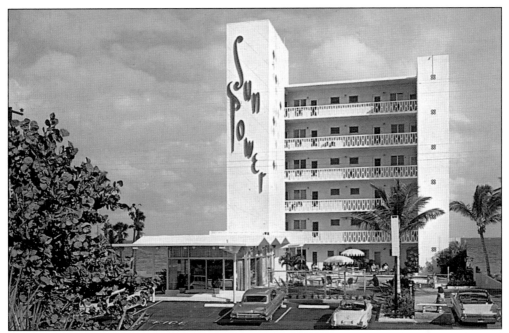

The 1960s saw a more intense development of the Fort Lauderdale's north beach area, beyond Sunrise Boulevard and Birch State Park. The "high rise" Sun Tower opened *c.* 1960 at 2030 North Atlantic Boulevard, and apartments and hotel rooms were located directly on the oceanfront. The Sun Tower offered elevators, a heated swimming pool, and—most covetously—covered parking. Today it is known as the Pelican Beach Resort. (P2766.)

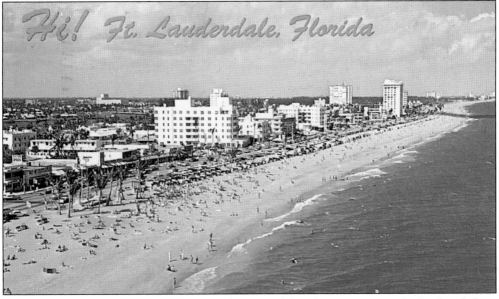

By the 1960s Fort Lauderdale's "strip" had filled in with hotels, restaurants, and other beach front businesses. The beach still attracted new crowds of tourists and new residents. This beachfront postcard sent in January 1969 features a message from the Hobes to Mrs. Spencer in Verona, Pennsylvania: "The weather is cool but invigorating." (P1525.)

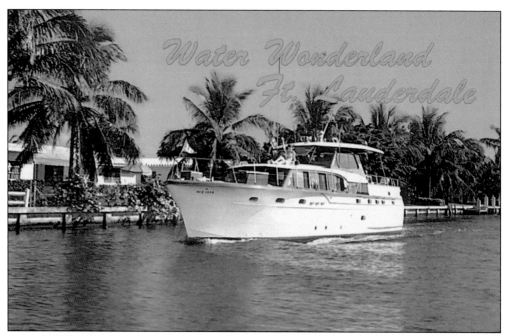

In the 1950s and 1960s, new developments featuring canals with "deep water access" at reasonable prices brought more and more boating and fishing enthusiasts to the area. A beautiful cabin cruiser on a local waterway, above, was the dream of many would-be residents. The scene below features "island living" near Las Olas Boulevard and beckons visitors to the "city of canals and beautiful homes." (P1495 and P1199.)

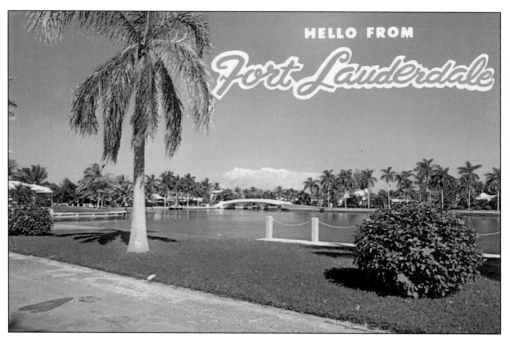

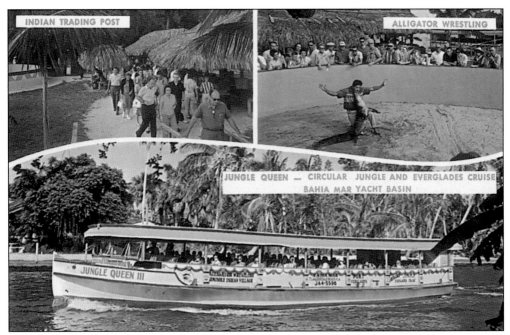

Capt. Al Starts introduced his sight-seeing cruise aboard the boat *Jungle Queen* to Fort Lauderdale in 1935. By the 1960s, the *Jungle Queen III* entertained tourists with a cruise through Fort Lauderdale's waterways, a barbecue dinner, and a visit to a Seminole attraction on an island in New River, west of today's I-95. Today the *Queen III* still plies local waters but is usually supplanted by her newer, larger sister, the "paddlewheeler" *Jungle Queen IV*. (P44.)

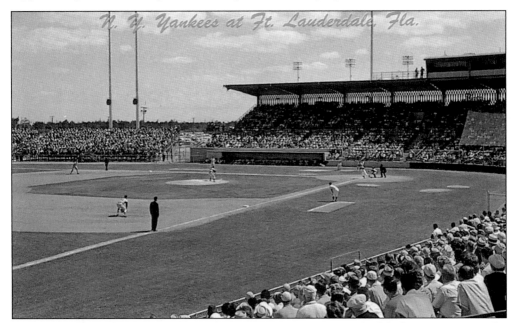

In 1962, the champion New York Yankees were lured to Fort Lauderdale for spring training by Fort Lauderdale's beautiful new baseball stadium, located at 5301 Northwest Twelfth Avenue. It quickly became known as Yankee Stadium and famous as yet another tourist attraction. (P1461.)

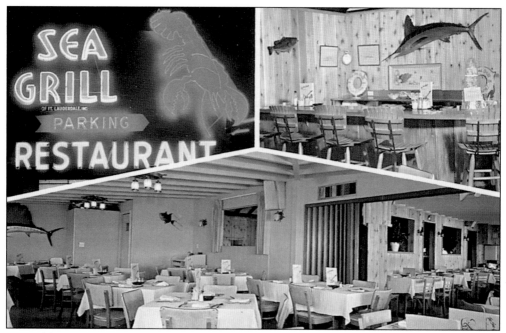

One of the city's most popular seafood restaurants, the Sea Grill, operated from the 1960s until the early 1990s on Northeast Fourth Avenue, across from Fort Lauderdale High School. Today the building has been converted to serve as a satellite for school board offices. (P2763.)

In the 1960s, drive-in restaurants were still a popular alternative to conventional diners. The Little Palace Drive In opened in the mid-1960s just off Sistrunk Boulevard at 606 Northwest Eighth Avenue. Proprietors Benny and Doris welcomed patrons "where old friends meet to eat. Our coffee is good and our food can't be beat." Today the Little Palace is a memory but the building survives as a medical office. (P2764.)

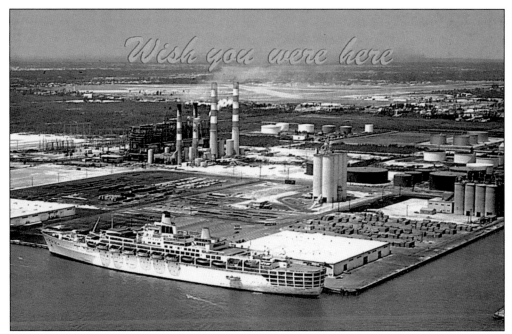

Port Everglades was still very much a cargo port in the 1960s but was "growing" its cruise ship activities. The interesting view above features the amusing slogan "Wish You Were Here"— presumably a reference to the glamorous destinations to be had via the port and the airport, visible in the background. In the late 1960s, the aging Cunard liner *Queen Elizabeth* found a home as a tourist attraction at the port. Attendance was not as hoped, and the *Queen* left in 1971, meeting a fiery end in Hong Kong in 1972. (P1447 and P1449.)

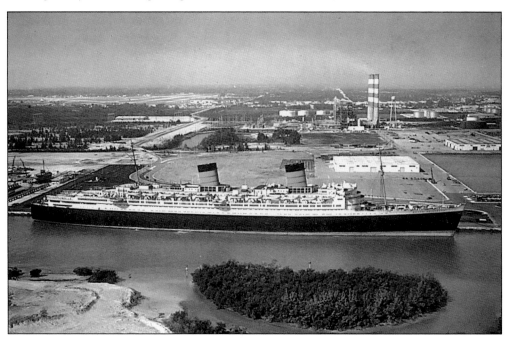

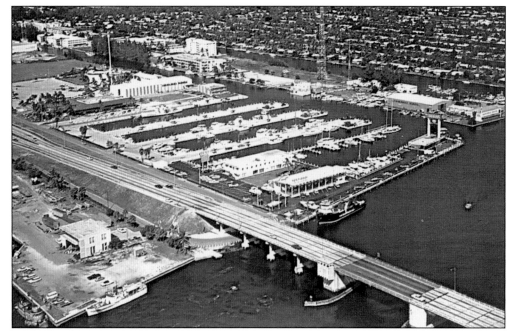

In 1957, the Seventeenth Street Causeway created a new link to the beach at the southern end of Fort Lauderdale. The bridge was named after Fort Lauderdale promoter Commodore Brook. This 1960s view reveals the docks and marine industries along the northwestern side of the bridge. The new attraction Ocean World is at the upper left. Today there is a new causeway and the Marina Marriott and other businesses have replaced the dockage. (P1469.)

A new marine attraction in Fort Lauderdale opened in 1965 just west of the Seventeenth Street Causeway. Billed as an "underwater world of wonder," it was well known for its dolphin shows. Ocean World closed after almost 30 years due to declining attendance and a lack of room for expansion. (P1613.)

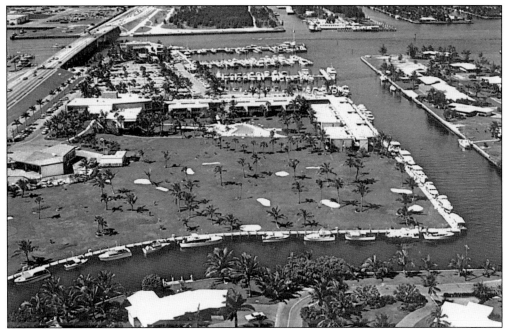

In 1957 Phillips Petroleum opened a private yacht club on the east and north side of the new Seventeenth Street Causeway, known as Pier 66. By the 1960s, it was a hotel on 22 acres featuring golf courses, two pools, and other facilities, shown looking west above. In 1965, Phillips opened the 17-story tower, on top of which perched the flying saucer–like, revolving lounge, shown below. Under new owners, Pier 66 is still one of Fort Lauderdale's most recognizable landmarks. (P2767 and P1382.)

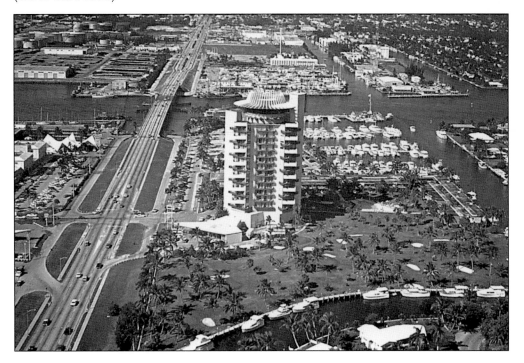

In the 1960s, this miniature train made Hugh Taylor Birch State Park Florida's most popular, taking visitors on a three-mile ride in and around the park. The train operated for almost 20 years, closing due to declining attendance and the aging of the original proprietor. (P2765.)

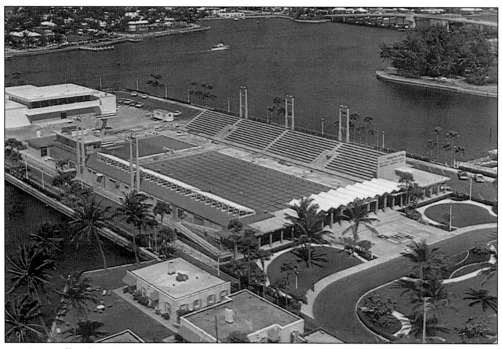

In a joint effort between swimming supporters and the City, the Swimming Hall of Fame and aquatic complex opened on Fort Lauderdale beach, just west of the site of the former Casino Pool in 1966. Today the International Swimming Hall of Fame continues to serve residents and visitors from around the world through its museum, beautiful pools, training facilities, and local, national, and international competitions. (P1547.)

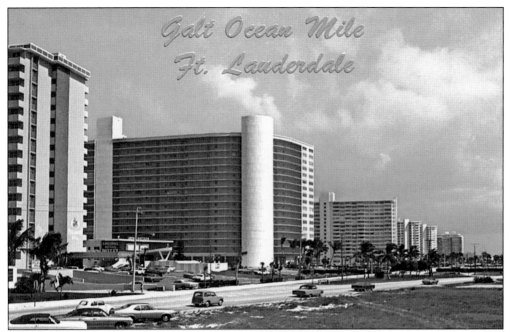

In 1953, Arthur Galt sold a tract of beachfront land north of Oakland Park Boulevard to Coral Ridge developers James Hunt and Stephen Calder. The Galt Ocean Mile quickly began to fill with new oceanfront condominiums. This postcard image is a view looking south from about 4200 Galt Ocean Drive (the building at center is The Galleon) in the late 1960s. (P1638.)

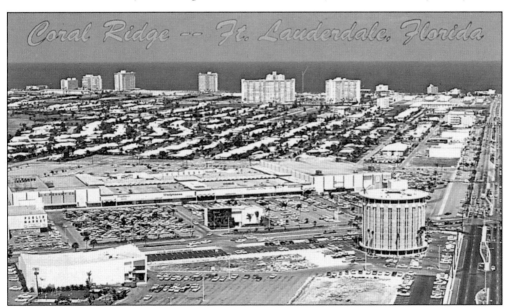

Fort Lauderdale grew dramatically in the 1960s due to the growth of the new northern subdivision of Coral Ridge, north of Sunrise Boulevard. This view shows the Coral Ridge Shopping Center, Fort Lauderdale's first enclosed mall, on Federal Highway and the then-recently widened Oakland Park Boulevard, looking east in the mid-1960s. The round skyscraper is the landmark Ken-Ann Building. (P1324.)

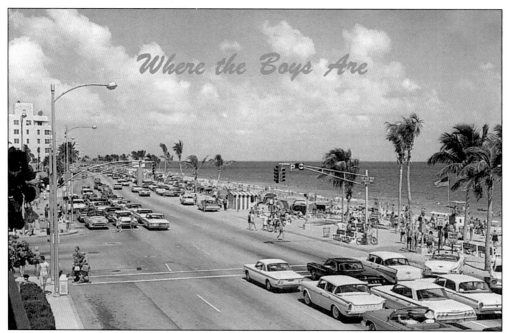

Where the Boys Are

By the 1960s, Fort Lauderdale had established a reputation as a destination for college students at Easter vacation, and the term "Spring Break" was born. Publicists for the area—and postcard manufacturers—did nothing to discourage this situation, which was always viewed with mixed feelings by the community. The boon to the local economy was often overset by the destruction wrought by overcrowding and bad behavior. Finally massive crowds in the 1980s forced students to seek other destinations. Above and below are two classic postcard scenes of the geographic center of Spring Break, the intersection of Las Olas and Atlantic Boulevard (A1A)—today Fort Lauderdale Beach Boulevard. (P1538 and P1470.)

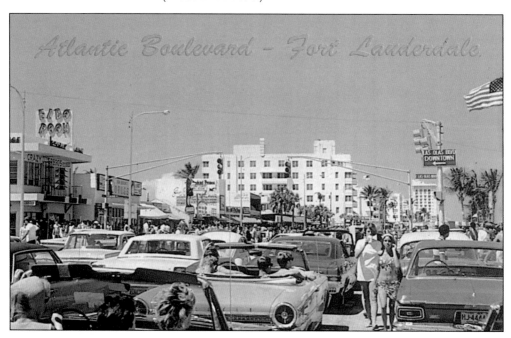

Atlantic Boulevard - Fort Lauderdale